WEST VIRGINIA

impressions

FARCOUNTRY
PRESS

photography by **Bryan Lemasters**
and **Steve Shaluta**

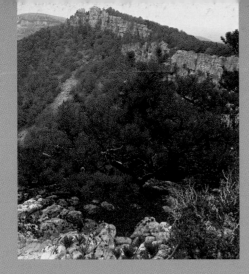

Above: North Fork Mountain—the most arid mountain in the Appalachians—features unusual varieties of flora, such as variable sage and beach heather. BRYAN LEMASTERS

Right: Autumn's finery accents Glade Creek Grist Mill, a fully operable mill that was constructed in 1976 from recycled materials from three older mills in the state. BRYAN LEMASTERS

Title page: The setting sun illuminates blueberry and huckleberry bushes in the Dolly Sods Wilderness, an area first explored in 1746. STEVE SHALUTA

Front cover: West Virginia's showy state flower, the rhododendron, ushers in the spring. STEVE SHALUTA

Back cover: The spectacular waterfalls of Blackwater Falls State Park plunge 63 feet into the gorge below. The "black" in the water is the result of tannic acid from sphagnum bogs and fallen hemlock and spruce needles. BRYAN LEMASTERS

ISBN 1-56037-333-4
Photography © 2005 by Bryan Lemasters and Steve Shaluta
© 2005 Farcountry Press

For more information about our books write Farcountry Press, P.O. Box 5630, Helena, MT 59604; call (800) 821-3874; or visit www.farcountrypress.com.

Created, produced, and designed in the United States. Printed in China.

09 08 07 06 05 1 2 3 4 5

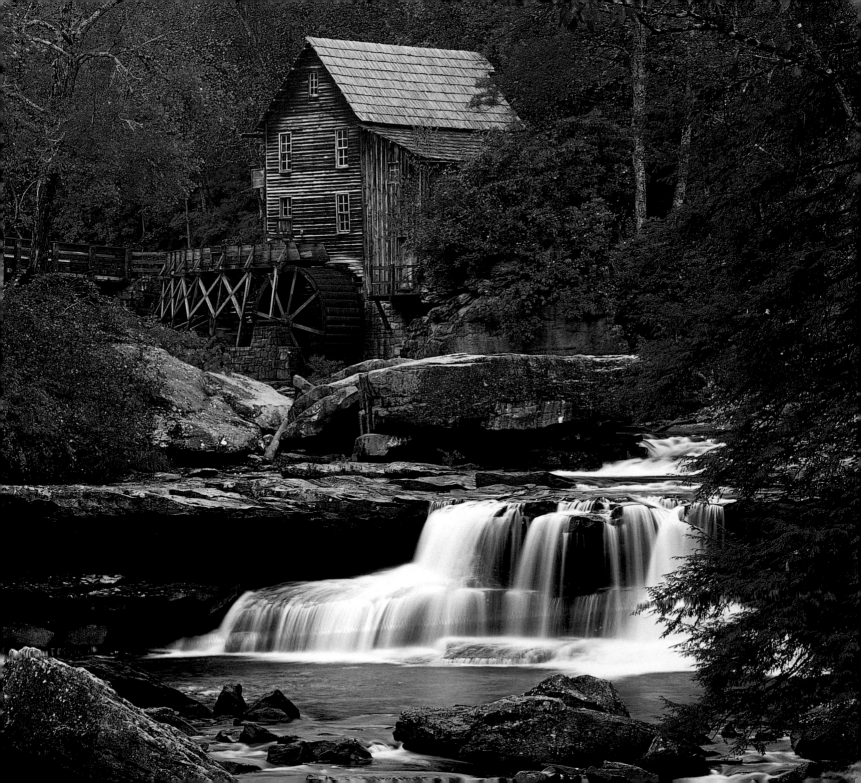

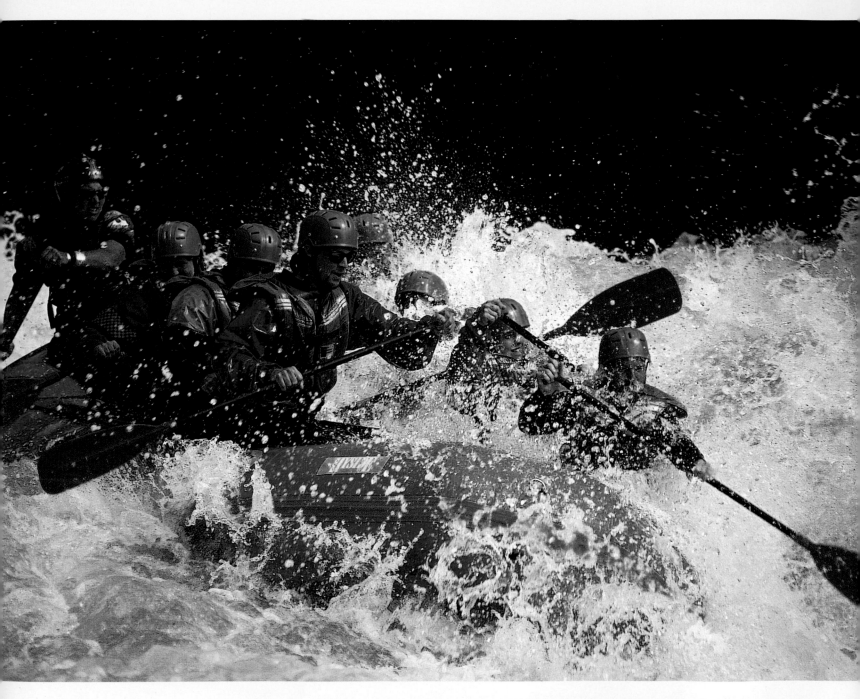

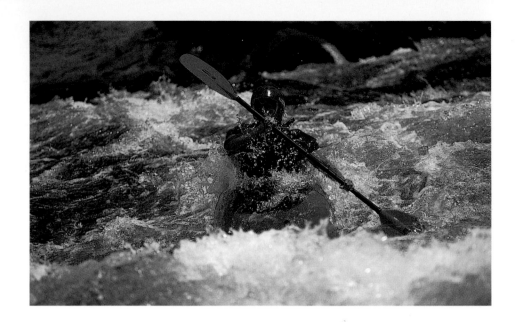

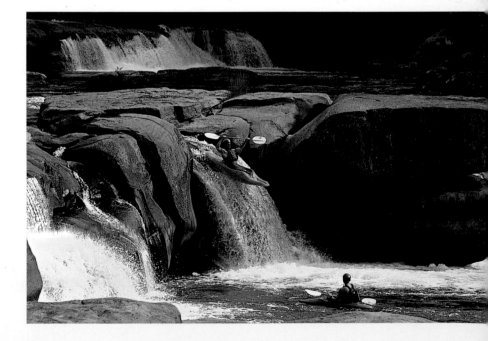

Above: A lone kayaker maneuvers through the Fayette Station Rapids in the New River Gorge National River, a class V challenge when the water is running high. STEVE SHALUTA

Right: Kayakers practice their skills on the surging waters of Valley Falls State Park.
BRYAN LEMASTERS

Left: Led by an experienced guide, rafters navigate the foamy Pillow Rock Rapid on the class V-plus Gauley River in Nicholas County. This river is one of the top seven whitewater rivers in the world.
STEVE SHALUTA

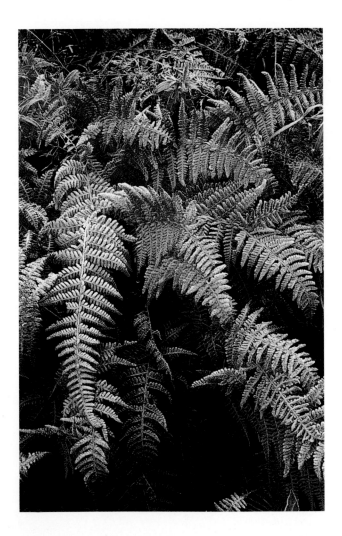

Right: Autumn frost tinges fern fronds in the Dolly Sods Wilderness, a high plain that rises from 2,600 to more than 4,000 feet in elevation. The name "Dolly Sods" came from one of the early pioneer families of the area, the Dahles, who used the local grazing land, or "sods," for their animals. BRYAN LEMASTERS

Far right: Nothing interrupts the stillness of an early winter morning on the Blackwater River in Canaan Valley Resort State Park. BRYAN LEMASTERS

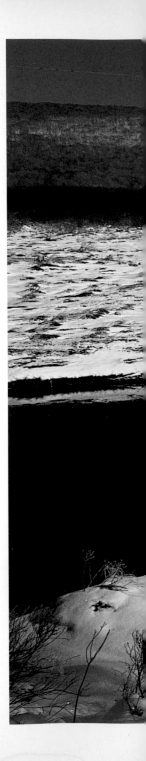

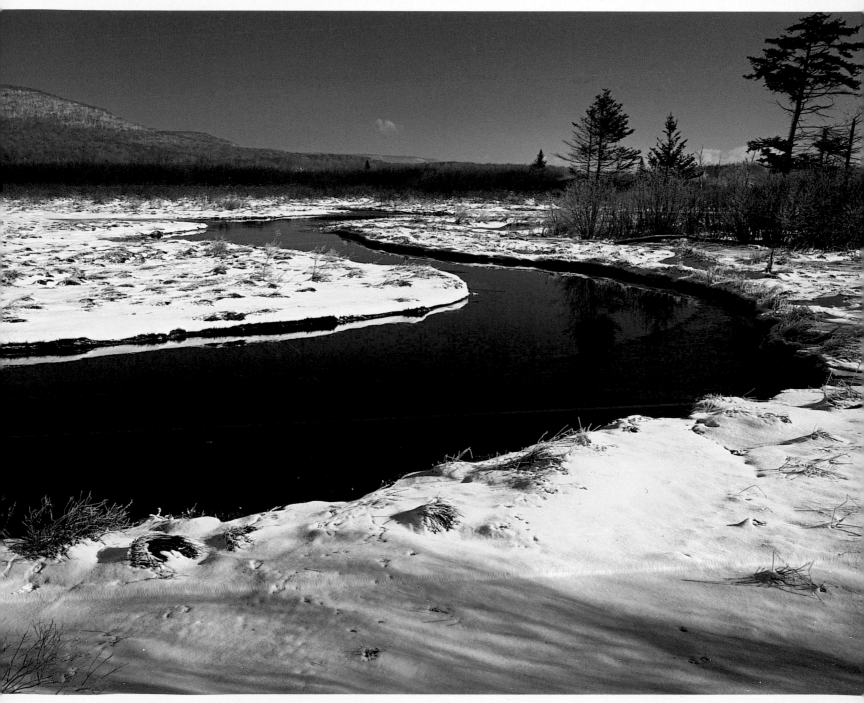

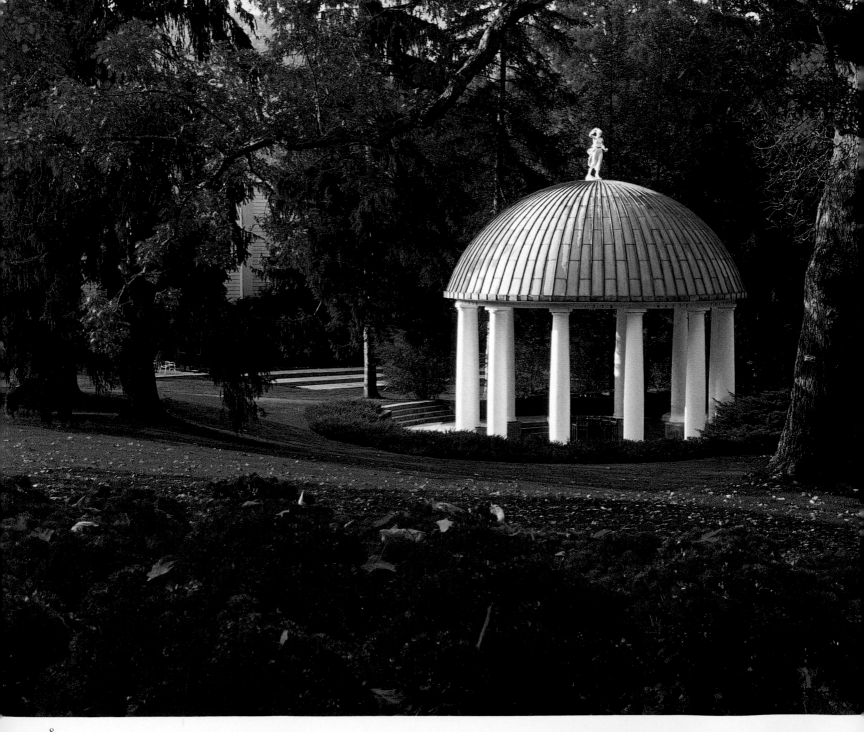

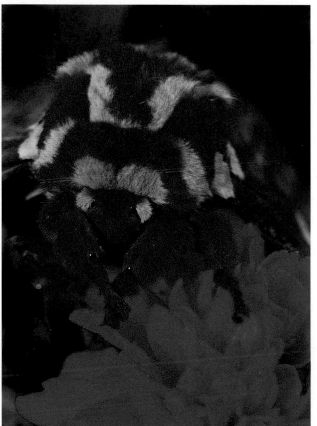

Above left: A moth's unique coloration is highlighted by the gold of a summer flower. STEVE SHALUTA

Above right: Scarlet maple leaves float lazily downriver in Babcock State Park, which offers 4,127 acres of rugged yet tranquil beauty. STEVE SHALUTA

Left: The columned Springhouse, a stately symbol of the famous Greenbrier Resort for generations, surrounds the sulphur springs where people have come to "take the waters" since 1778. STEVE SHALUTA

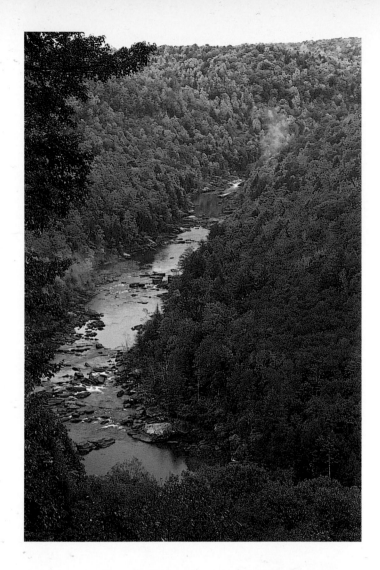

Above: The Civil War–era Carnifex Ferry Battlefield State Park is perched on the rim of the Gauley River Canyon. From the canyon, the beleaguered Confederates retreated on September 10, 1861, unable to gain control of the Kanawha Valley. BRYAN LEMASTERS

Right: At 3,030 feet, the graceful New River Gorge Bridge, built in 1974, is one of the longest steel-arch bridges in the world. This impressive feat of engineering spans the serene waters of the New River, 876 feet below. STEVE SHALUTA

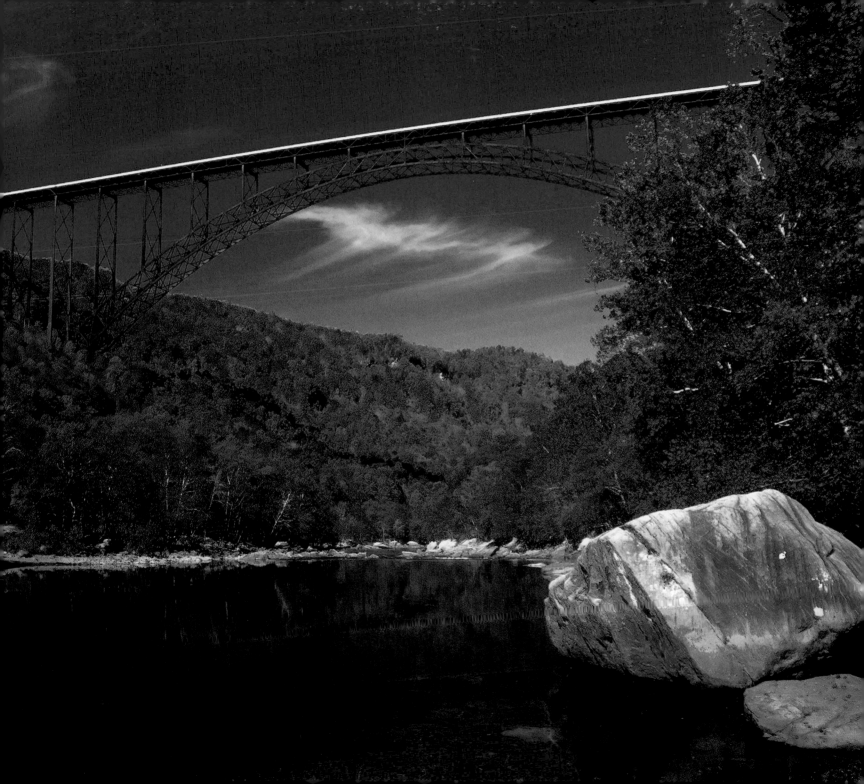

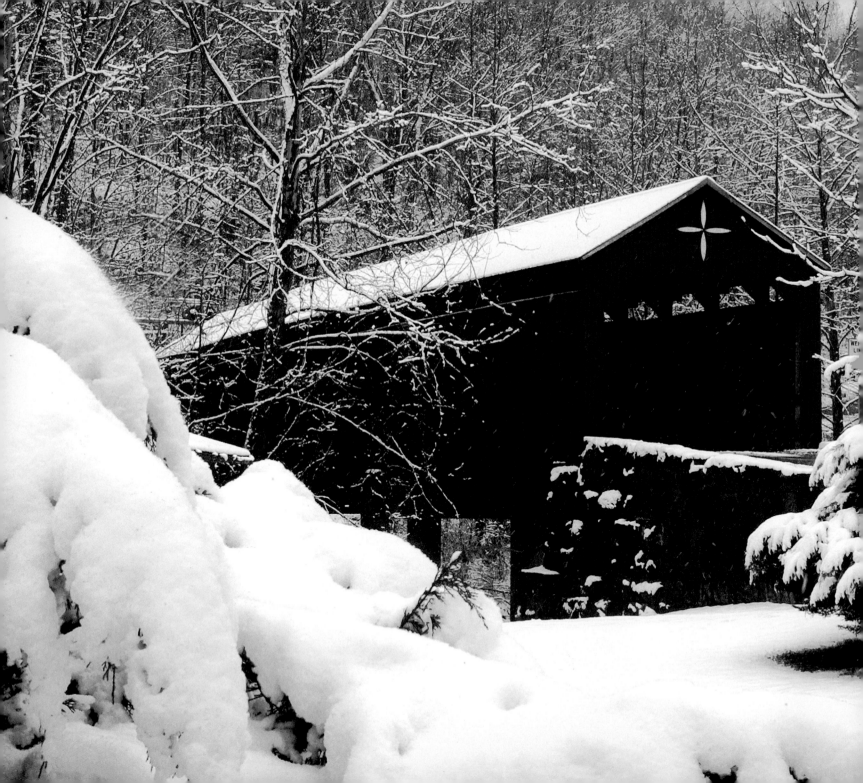

Left: The Carrollton Covered Bridge, built in 1856, is one of two remaining covered bridges in Barbour County. STEVE SHALUTA

Below: Icicles frame a small waterfall on Whites Run in Pendleton County. BRYAN LEMASTERS

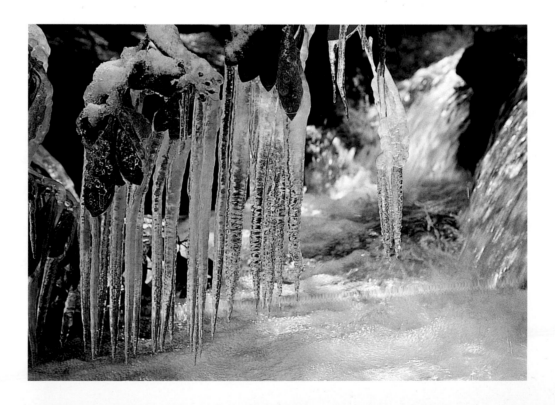

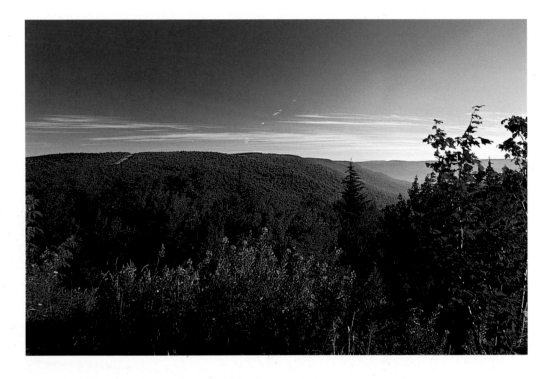

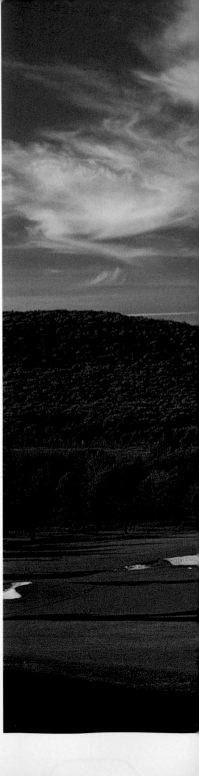

Above: A panorama of the Allegheny Highlands greets motorists along the Highland Scenic Highway in Pocahontas County. STEVE SHALUTA

Right: Golfers enjoy a quiet game on the Canaan Valley Golf links in Tucker County. STEVE SHALUTA

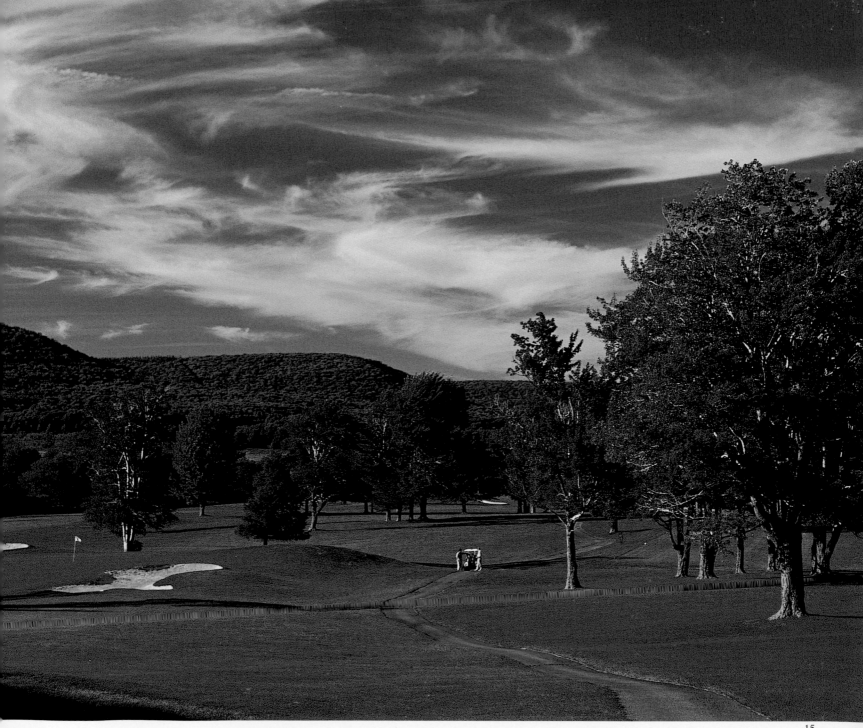

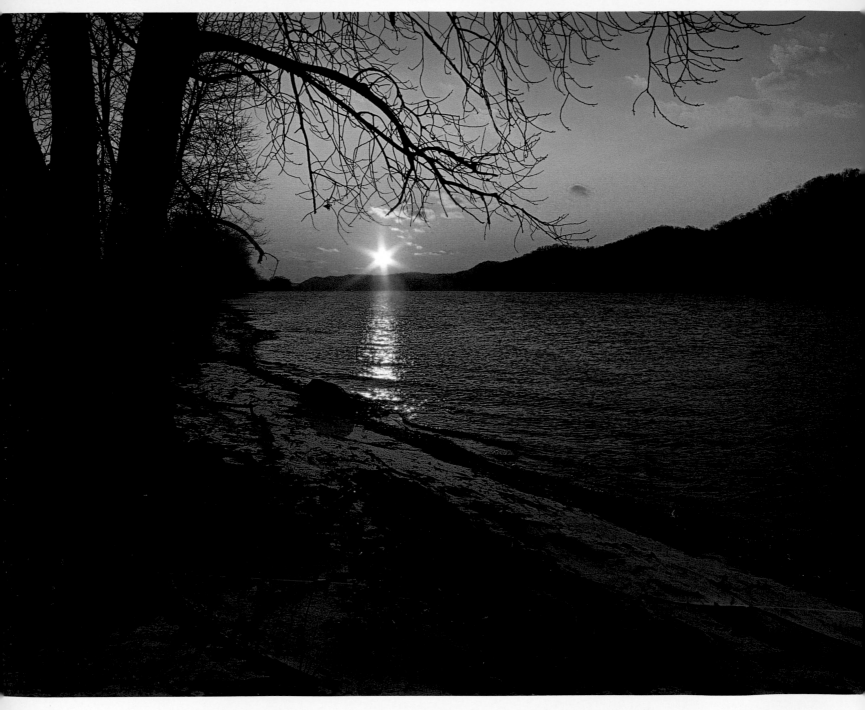

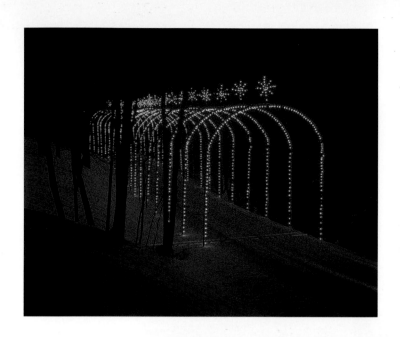

Left: Christmas is a magical time at 1,650-acre Oglebay Resort near Wheeling. Visitors wend their way through the twinkling Snowflake Tunnel, part of the resort's nationally renowned holiday light show. STEVE SHALUTA

Far left: The sun sets on the Ohio River near Paden City. BRYAN LEMASTERS

Below: Built in the 1852, the Phillippi Covered Bridge in Barbour County was the site of an attack on June 3, 1861, when Union forces surprised Confederate soldiers. Union troops claimed the day's victory. BRYAN LEMASTERS

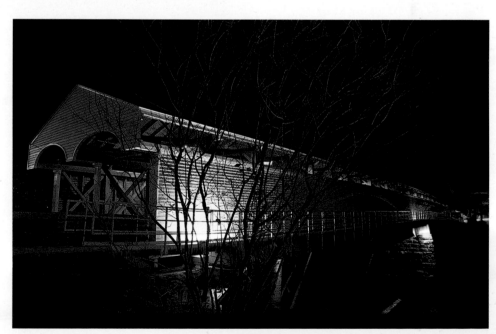

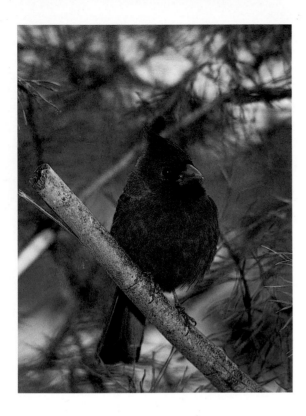

Above: A male cardinal, West Virginia's state bird, surveys his surroundings. STEVE SHALUTA

Right: From delicate blown glass to hand-sewn quilts, the wares displayed and sold in the Tamarack Center in Beckley showcase the talents of state artisans. Artists frequently demonstrate their crafts in the Center. STEVE SHALUTA

Below: The elegant wake-robin trillium, which flowers from April to June in deep woods, is a member of the lily family. BRYAN LEMASTERS

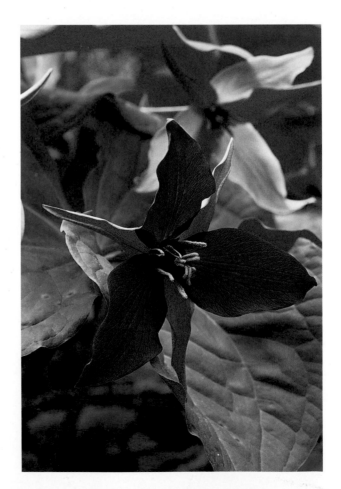

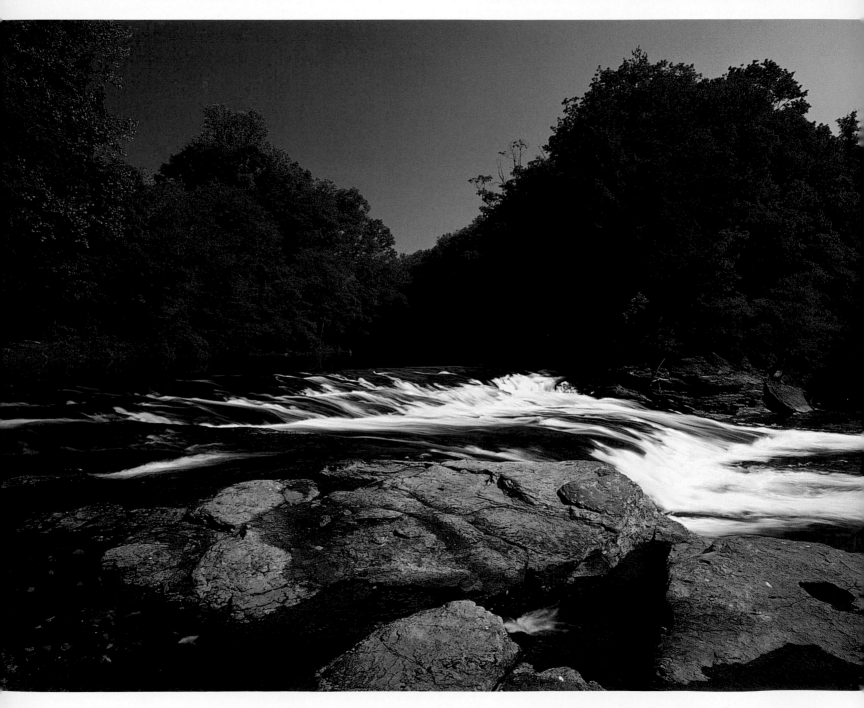

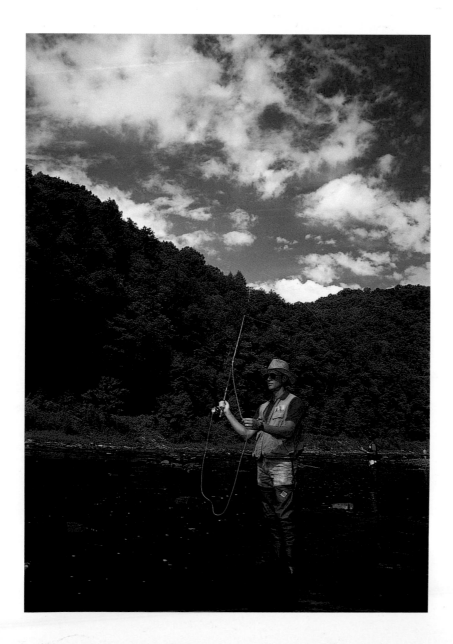

Left: Anglers enjoy fly fishing on the Greenbrier River, the largest free-flowing river in the East. A walking and biking trail runs alongside the river for 78 miles, from Cass to Caldwell. STEVE SHALUTA

Far left: At Falls Mill in Braxton County, a placid waterfall is flanked by rocky ledges. STEVE SHALUTA

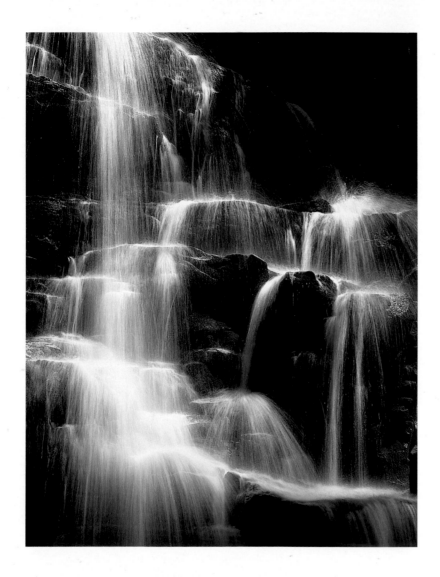

Above: Cascades of water and light shimmer at Blackwater Falls State Park in Tucker County. BRYAN LEMASTERS

Right: One of three waterfalls at Hills Creek in Pocahontas County, the Lower Falls splashes 63 feet to the waiting pool below. This beautiful spot is tucked away in a narrow gorge off the Highland Scenic Highway. BRYAN LEMASTERS

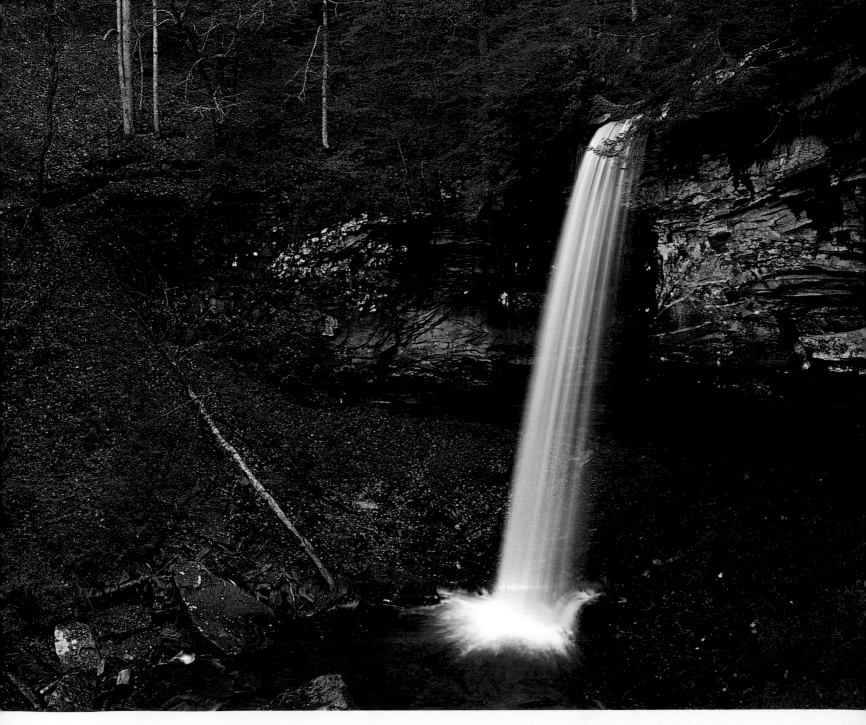

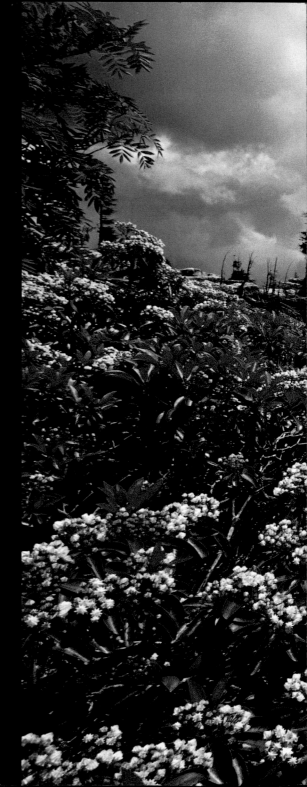

Right: Mountain laurel and flagged trees offer a signature view of the West Virginia landscape in the Bear Rocks Preserve. Flagged trees have limbs that grow in only one direction because of the continual alpine winds blowing from the west. STEVE SHALUTA

Below: Cathedral State Park's virgin hemlock forest provides a glimpse into the history of the ancient woods that flourished widely in the Appalachian Mountains. The trees are up to 90 feet tall and 21 feet in circumference. BRYAN LEMASTERS

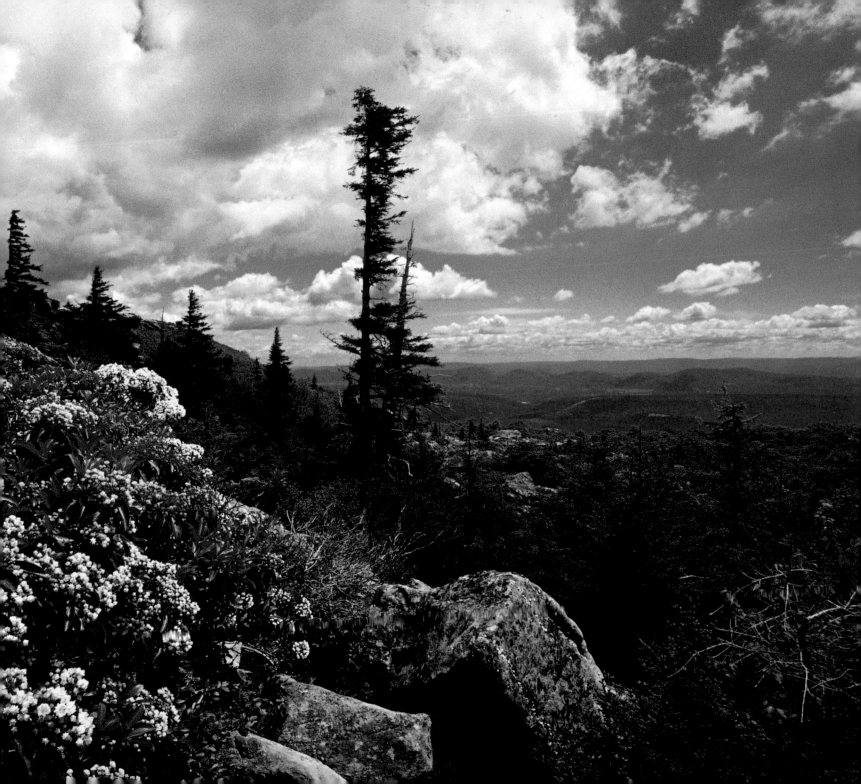

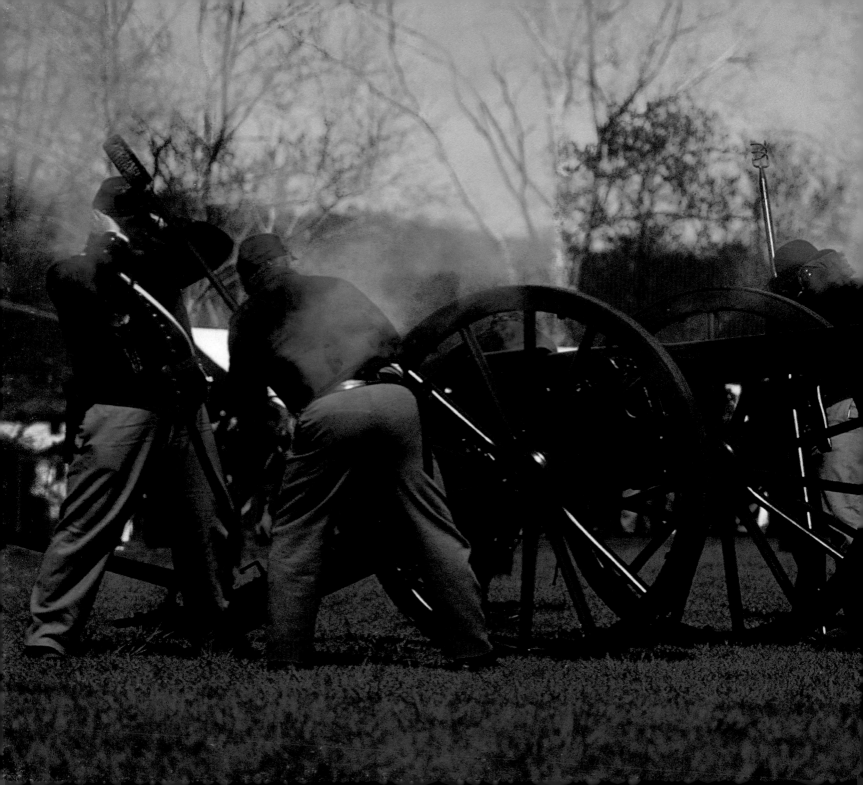

Left: Dedicated Civil War reenactors recall the Battle of Scary Creek, which occurred June 17, 1861. Entrenched Confederate troops took on a Union assault until they were forced to retreat up the valley to Gauley Bridge. STEVE SHALUTA

Below: Memorial Day flags commemorate the veterans who are buried in the Grafton National Cemetery. The cemetery was originally appropriated in 1867 for the permanent interment of Union and Confederate soldiers throughout the state who had died in battle or of their war wounds. STEVE SHALUTA

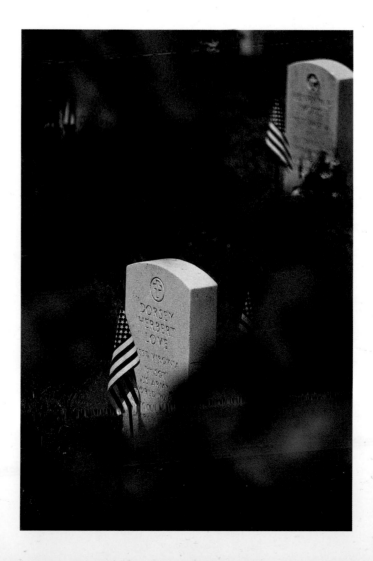

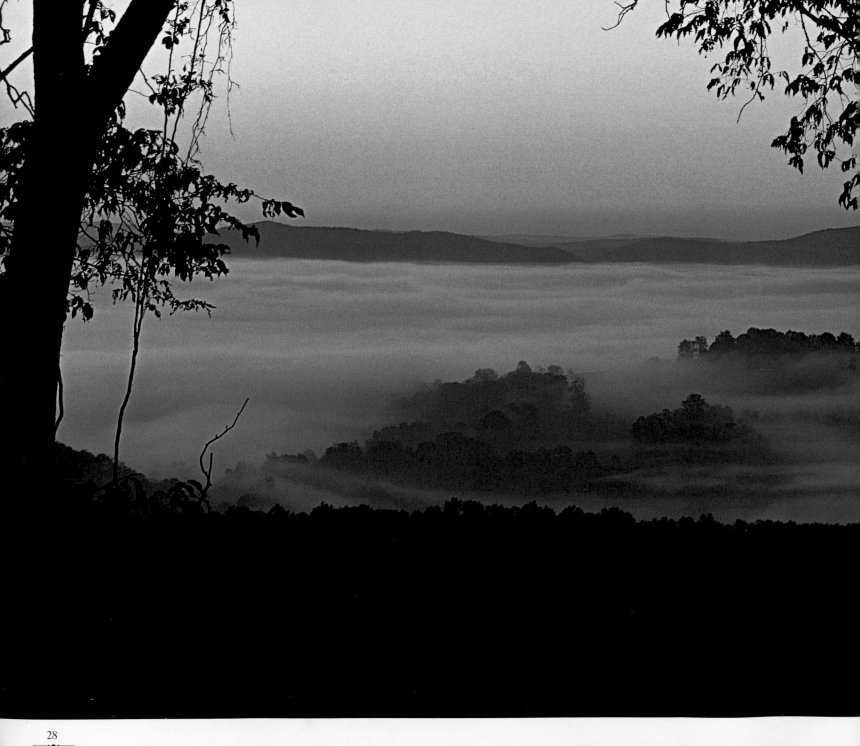

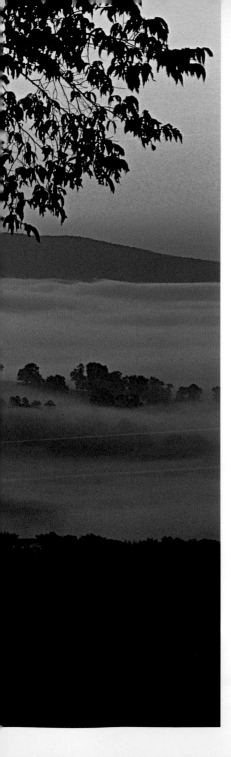

Left: Early morning fog obscures much of the Greenbrier Valley from view. Over the years, the rich abundance of natural resources in this area has attracted settlers and explorers. BRYAN LEMASTERS

Below: Profusions of pink laurel blossoms growing in the Allegheny Highlands are highlighted by the rising sun. BRYAN LEMASTERS

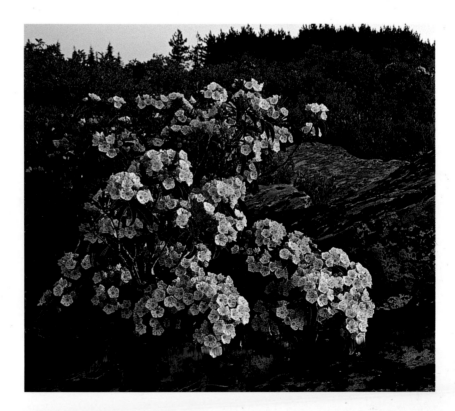

Right: Cross-country skiers enjoy a good workout on the Lindy Run Trail in Blackwater Falls State Park. More than ten miles of groomed trails offer challenges for novice and experienced skiers. STEVE SHALUTA

Far right: This landmark Mail Pouch Barn in Jackson County is just one of a number of rural buildings in West Virginia that sport the Mail Pouch Chewing Tobacco logo. Photographing this unusual form of advertising is a favorite pastime for amateur and professional photographers. BRYAN LEMASTERS

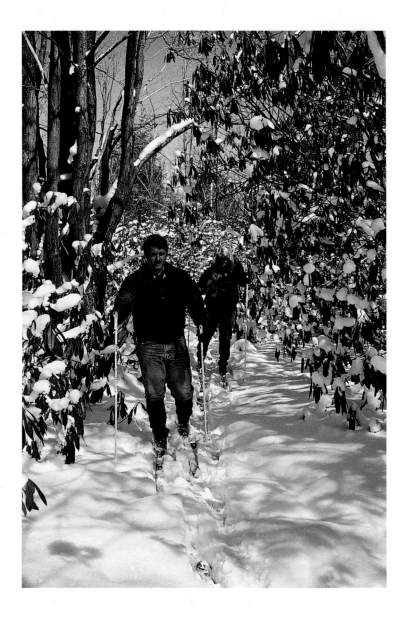

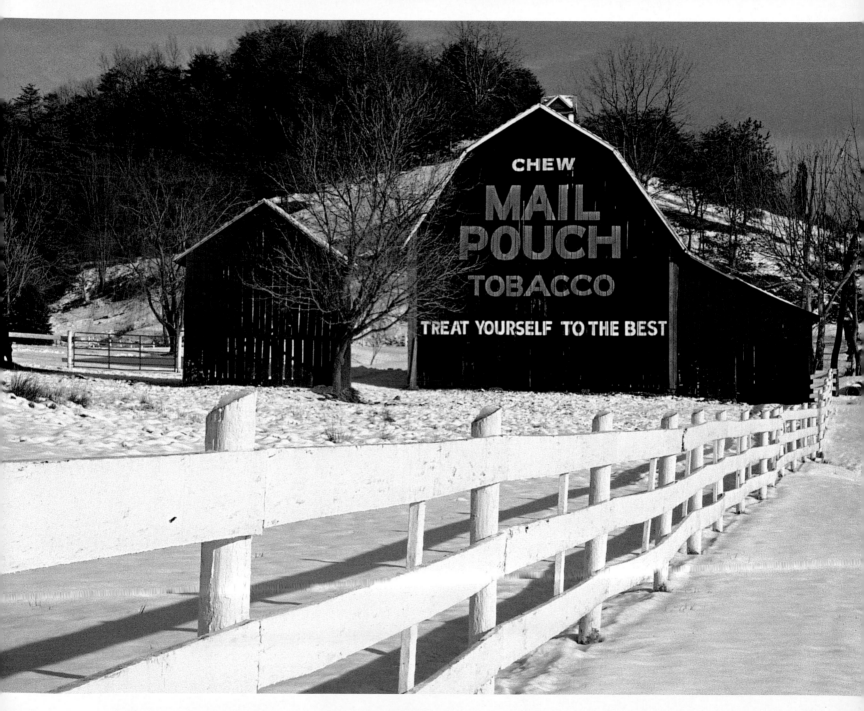

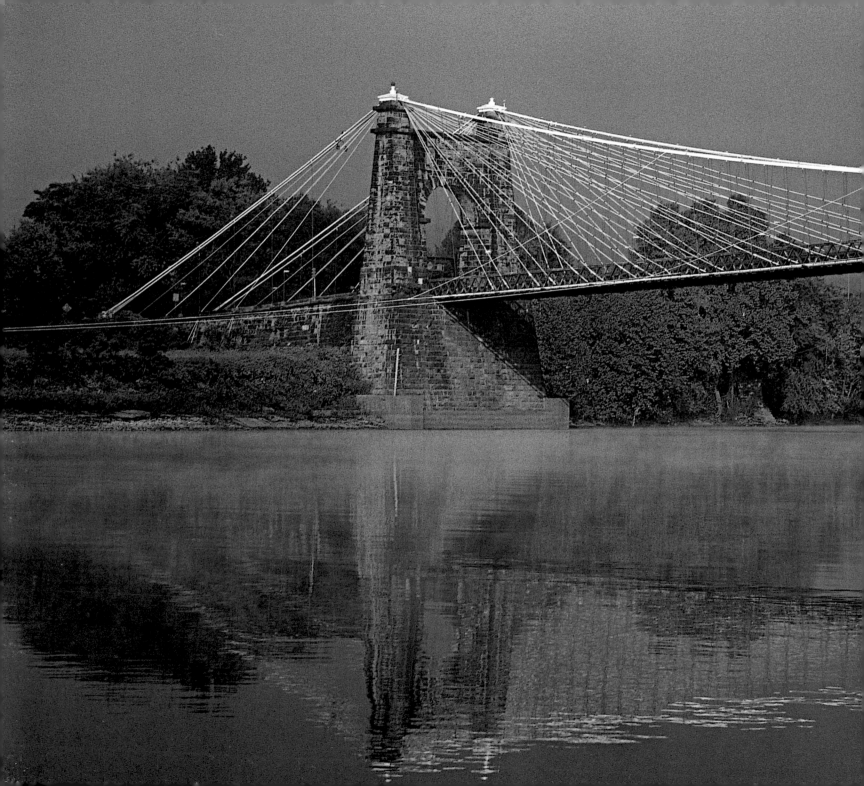

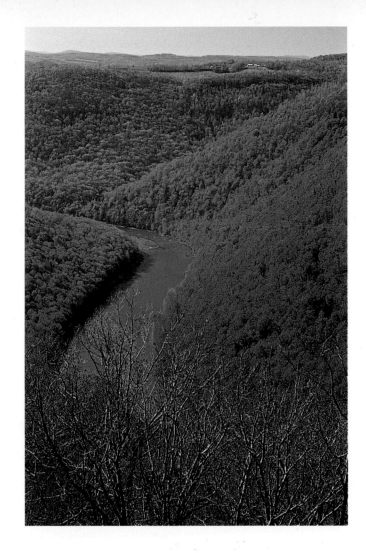

Above: About 16 miles long, the class IV to class V Cheat River Canyon is flanked by Pottsville sandstone and steep forested hillsides. One of the world's rarest land snails, the Cheat threetooth, resides in the cliffs and rocky areas overlooking the river. BRYAN LEMASTERS

Left: In 1849, citizens of Wheeling celebrated the formal opening of the first wire suspension bridge to span the Ohio River. The original bridge fell during high winds in 1854 but was rebuilt several years later. BRYAN LEMASTERS

Right: This view of historic Harpers Ferry shows a quiet town, but the community has witnessed much strife, including John Brown's attack on slavery, the largest surrender of Union troops in the Civil War, and the establishment of one of the first integrated schools in the United States. STEVE SHALUTA

Below: The charming red brick Mount Zion Episcopal Church was constructed in 1818, replacing an earlier meeting house on the site. The church predated the town of Hedgesville by some 14 years. BRYAN LEMASTERS

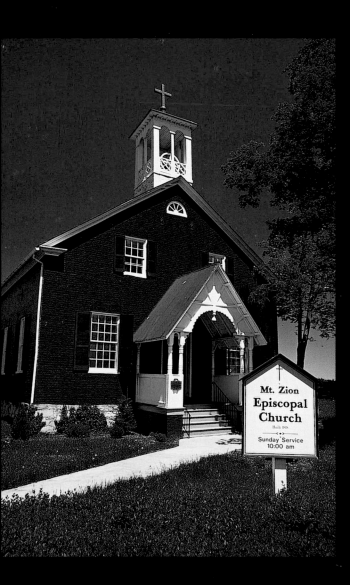

Mt. Zion
**Episcopal
Church**
Bath ISS
—‹•›—
Sunday Service
10:00 am

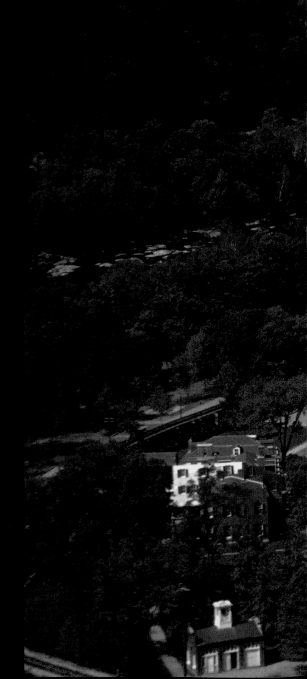

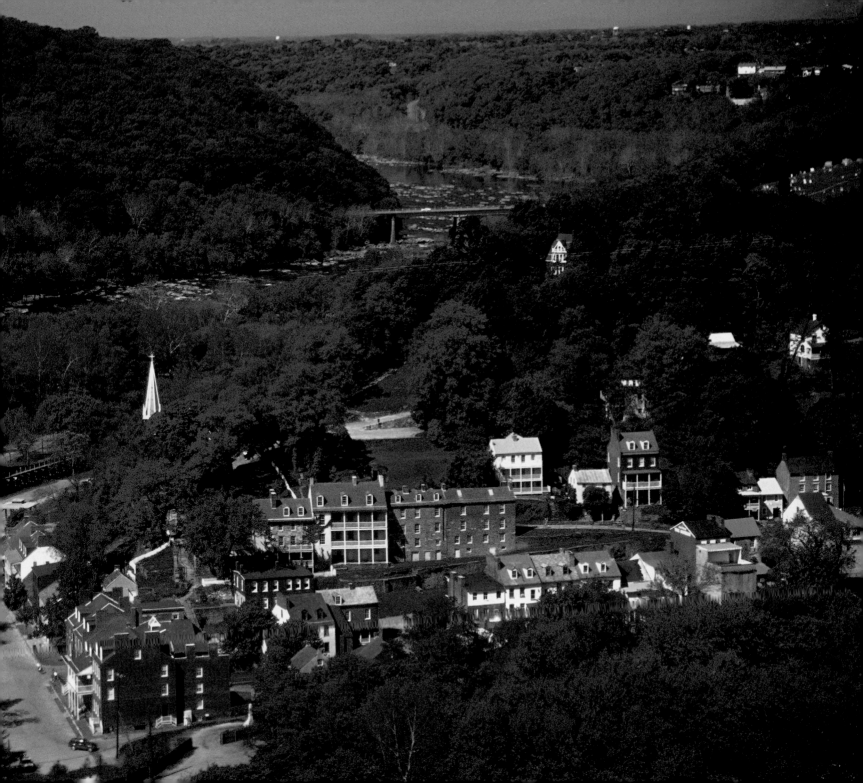

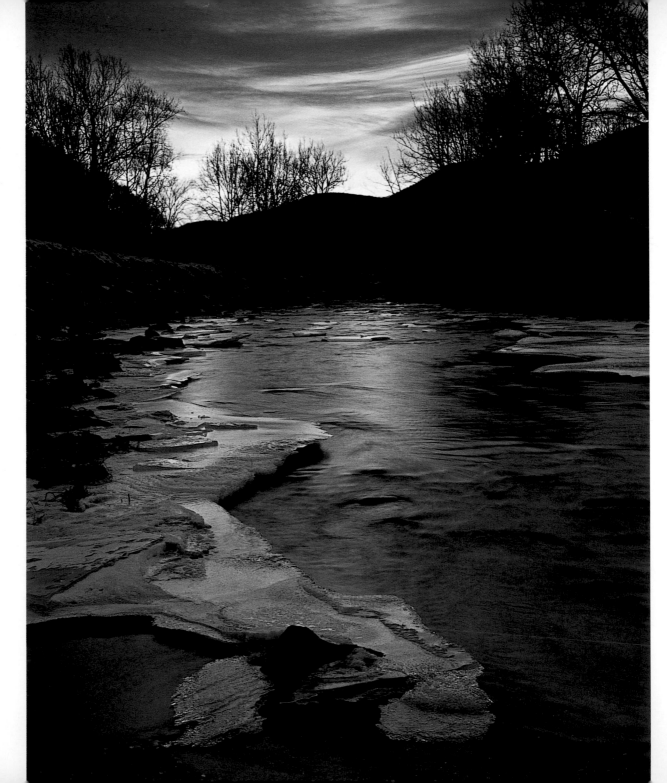

Right: A winter sunset glows on the partially frozen North Fork of the South Branch River in Pendleton County.
BRYAN LEMASTERS

Above: Ranging in color from pale pink to vivid magenta, the fringed polygala, or gaywings, grows in moist woods and blooms in May and June. STEVE SHALUTA

Right: The crested dwarf iris, which inhabits wet forests and hills of West Virginia, provides a delicate floral display in spring. STEVE SHALUTA

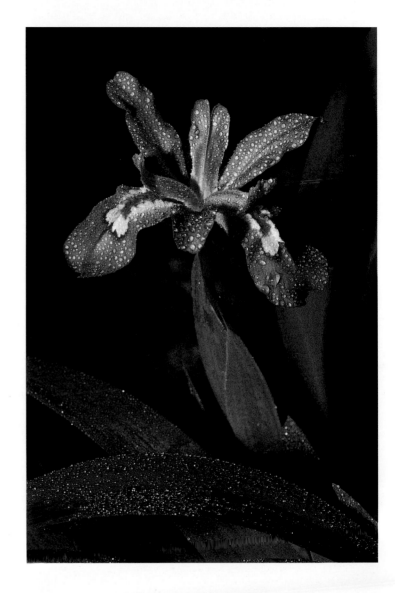

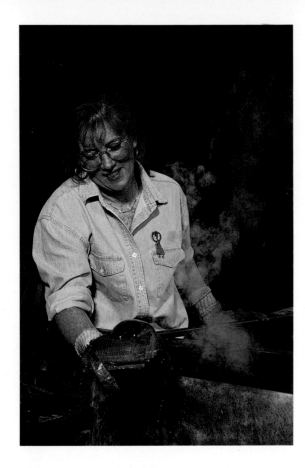

Right: The feud between the Hatfields and the McCoys erupts once again in a drama at the Cliffside Ampitheatre at Grandview. Part of New River Gorge National River Park, Grandview is the site of numerous summer theatre presentations. STEVE SHALUTA

Below: An artisan fashions a sweet-stringed dulcimer at the annual Mountain State Arts and Crafts Fair in Cedar Lakes in Ripley Jackson County. The rich tradition of Appalachian music features a variety of instruments, including dulcimers, guitars, banjoes, and fiddles. STEVE SHALUTA

Above: Local artist Marylin Holt demonstrates the intricate craft of glass blowing in an Elkview studio.
STEVE SHALUTA

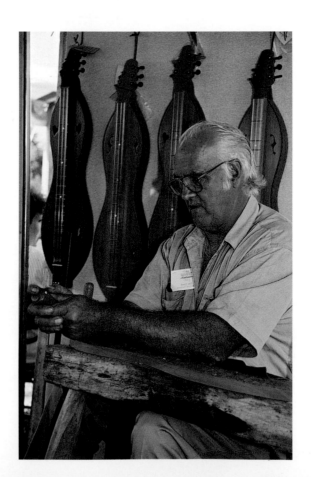

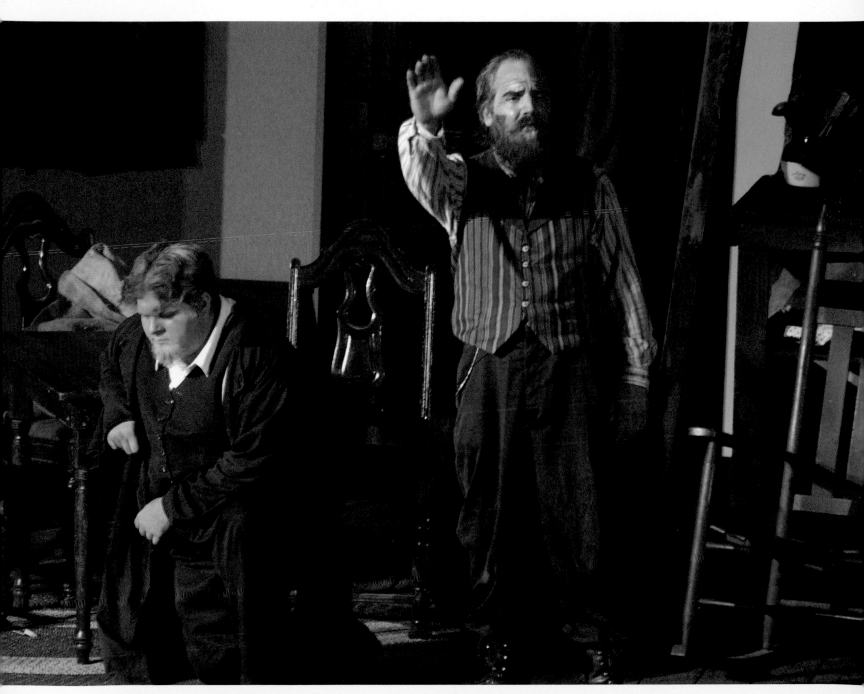

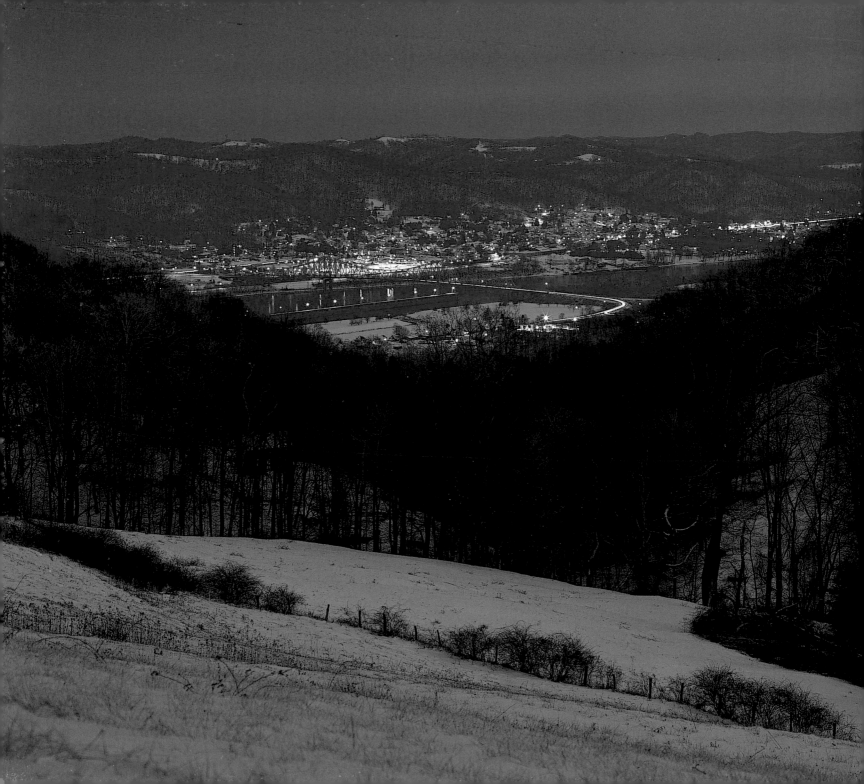

Left: Twinkling lights glow amidst the snow-covered landscape of New Martinsville. BRYAN LEMASTERS

Below: Horses graze in a rural section of Wetzel County that is blanketed white by a recent snowstorm. BRYAN LEMASTERS

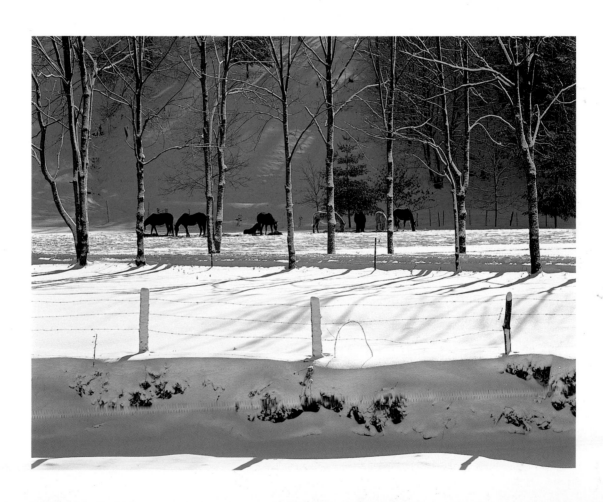

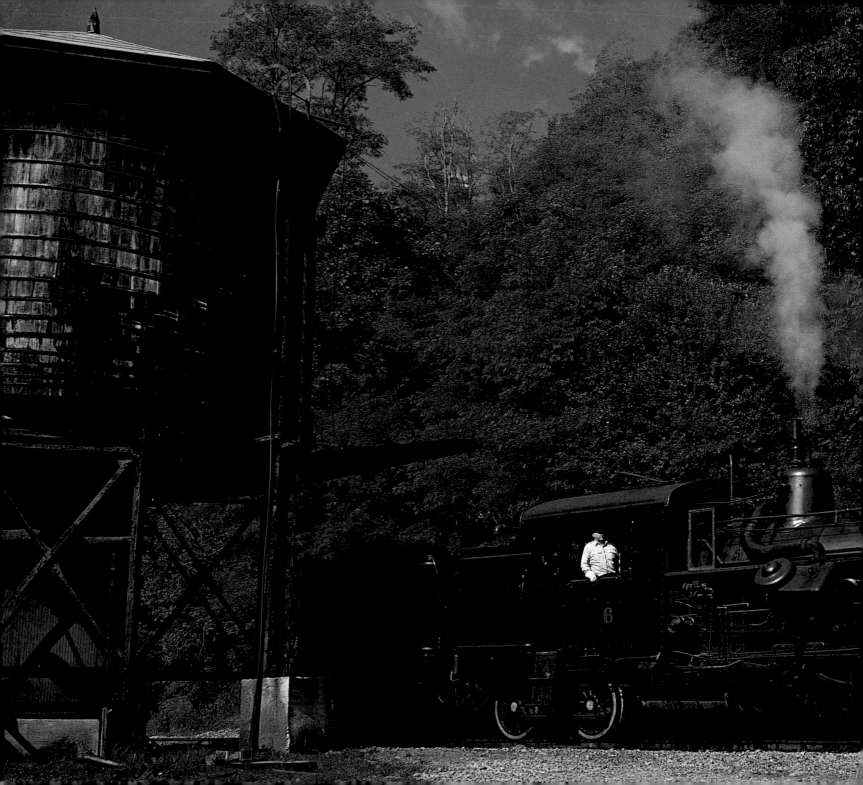

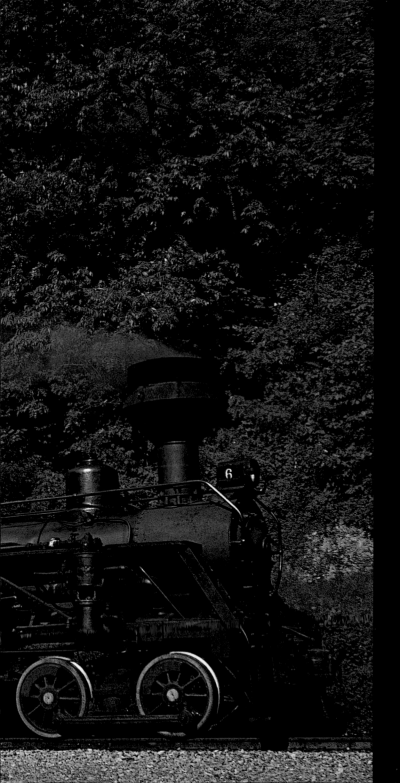

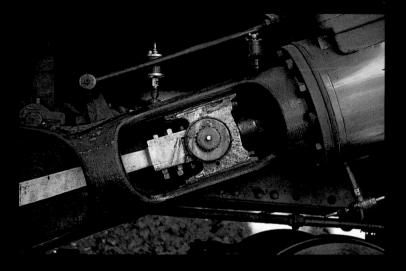

Above: A detail shot reveals the intricate mechanisms of Old No. 3, one of three working Climax-geared locomotives still in existence. This behemoth was constructed in 1910 and hauled timber and coal in the 1950s on the Durbin and Greenbrier Railroad. BRYAN LEMASTERS

Left: The reconstructed logging town of Cass is situated in the Allegheny Mountains. A few trains of yesteryear, like this Heisler steam engine, still transport passengers on the switchbacks along the Cass Scenic Railroad. STEVE SHALUTA

Above: Fall colors blaze along the Wetzel/Marion County line that is located at the base of West Virginia's northern panhandle. This area features bottom land along the Ohio River as well as rugged and hilly areas.
BRYAN LEMASTERS

Facing page: After cool nights and crisp days, autumn reddens the pastoral setting of Reader in Wetzel County.
BRYAN LEMASTERS

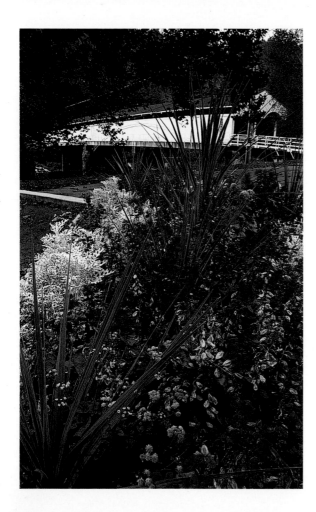

Right: The sophisticated telescopes of the National Radio Astronomy Observatory in Green Bank tower above a bucolic Greenbrier Valley farm. BRYAN LEMASTERS

Below: The West Virginia Italian Heritage Festival, a street festival held every year in late summer, celebrates the culture of Italian-Americans with pageantry, entertainment, contests, exhibitions, and plenty of Italian cuisine. STEVE SHALUTA

Above: Summer flowers provide a bright foreground for a somber site: the historic covered bridge at Phillippi in Barbour County that many consider to be the site of the first Civil War land battle.
BRYAN LEMASTERS

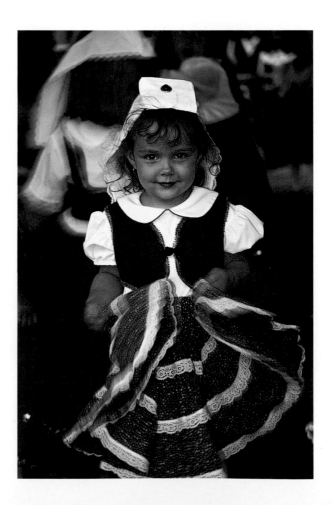

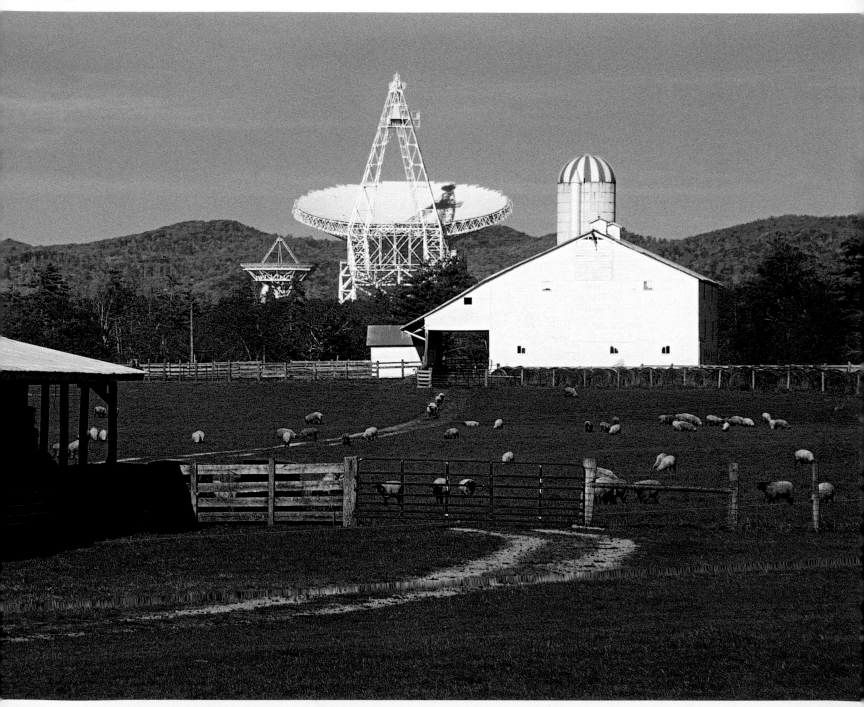

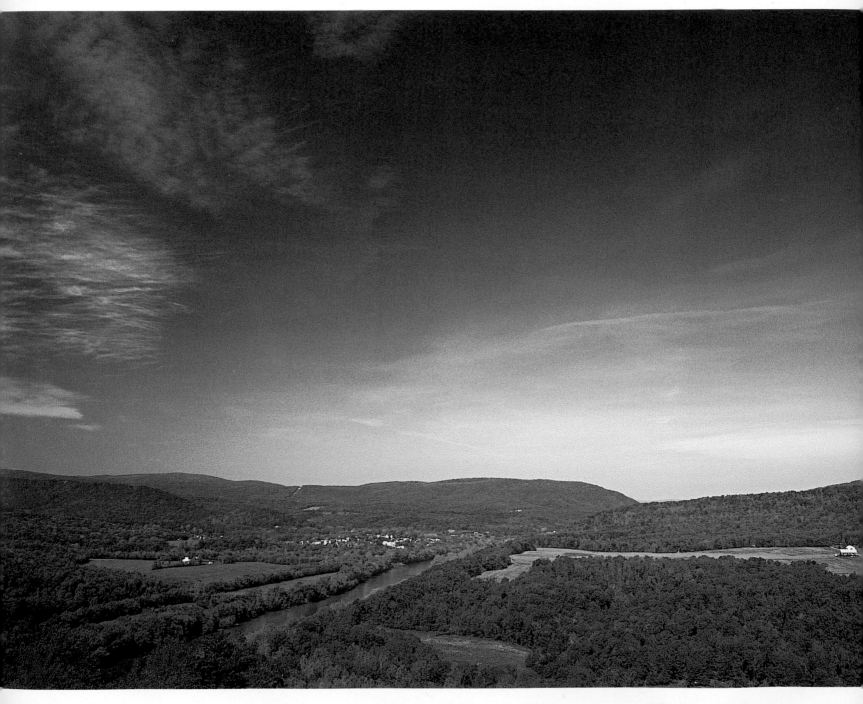

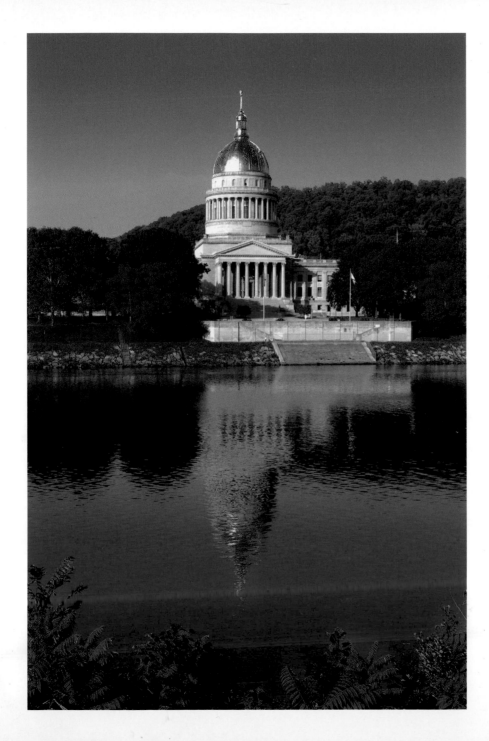

Left: After two earlier capitol buildings in Charleston were destroyed by fire, this 1932 structure was constructed of buff limestone. The building boasts a 293-foot-high gold dome and elaborately carved brass and copper doors and overlooks the wide Kanawha River. STEVE SHALUTA

Far left: The Potomac River, which has been sculpting the landscape for millions of years, winds through scenic Morgan County. Prospect Park is a favorite viewing point overlooking the river.
BRYAN LEMASTERS

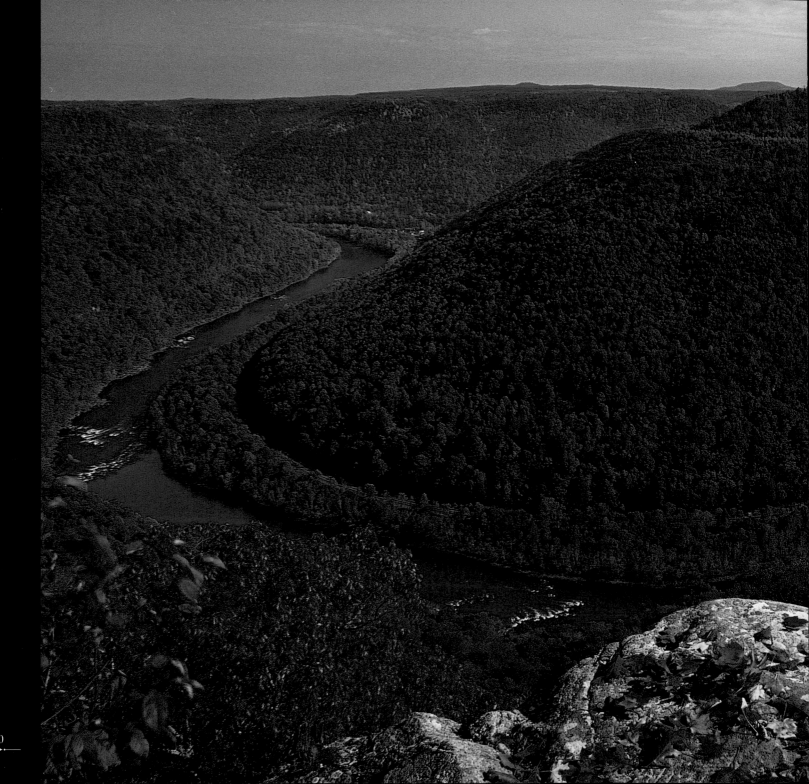

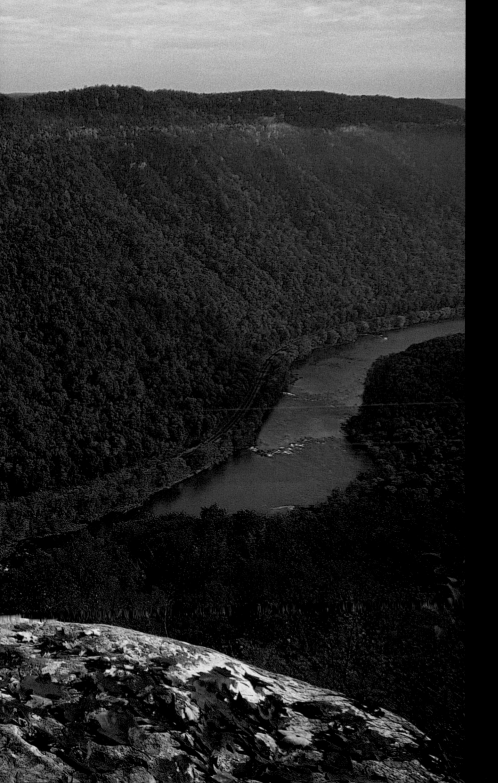

The New River meanders through a landscape lit with fall foliage in the Grandview area of Raleigh County. This rugged whitewater river, flowing northward through deep canyons, is one of the oldest rivers on the continent. STEVE SHALUTA

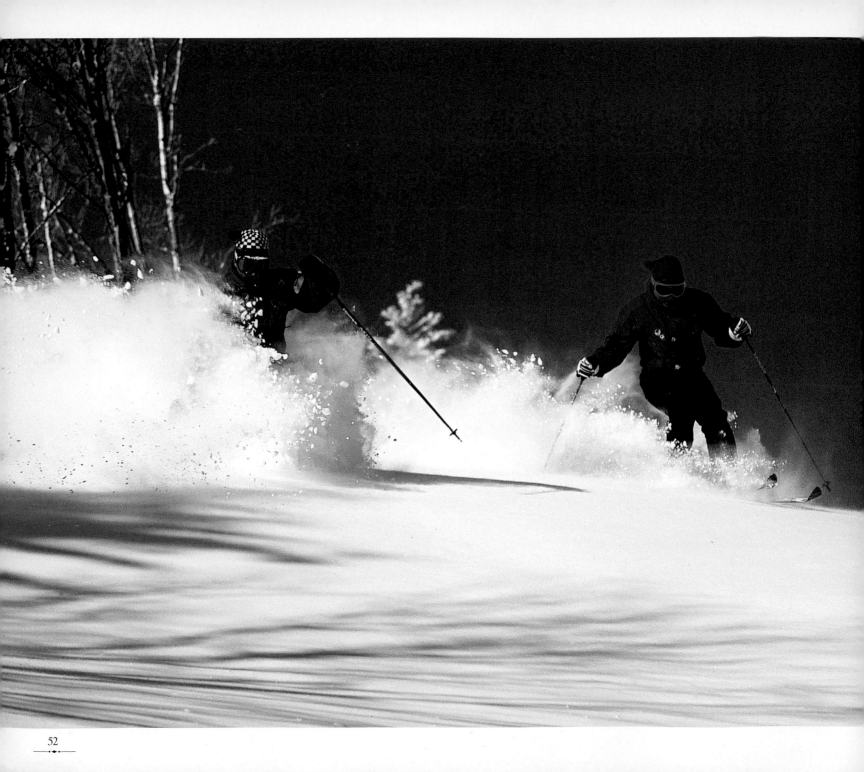

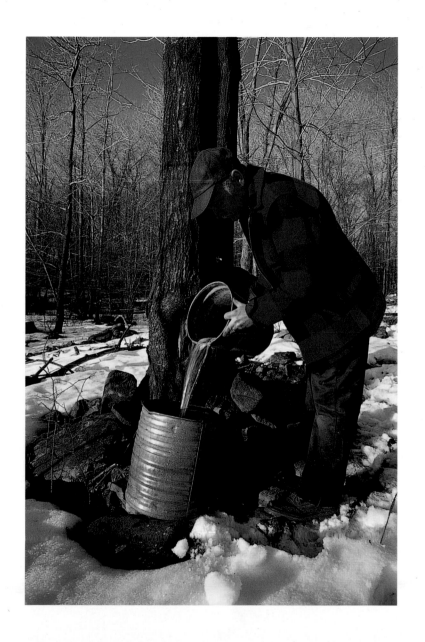

Left: In Randolph County, resident Mike Ritcher taps a maple tree—the state's official tree—for sap that is used to make syrup. STEVE SHALUTA

Far left: Skiers fly through fresh powder at the Snowshoe Mountain Resort in Pocahontas County. At 4,848 feet, it is the largest winter resort in the mid-Atlantic and features 57 slopes and a 1,500-foot vertical drop. STEVE SHALUTA

The early morning sun burnishes
a barn along Route 92 in rural
Pocahontas County. This pastoral
setting is home to a number of
bed-and-breakfast inns and
homesteads. STEVE SHALUTA

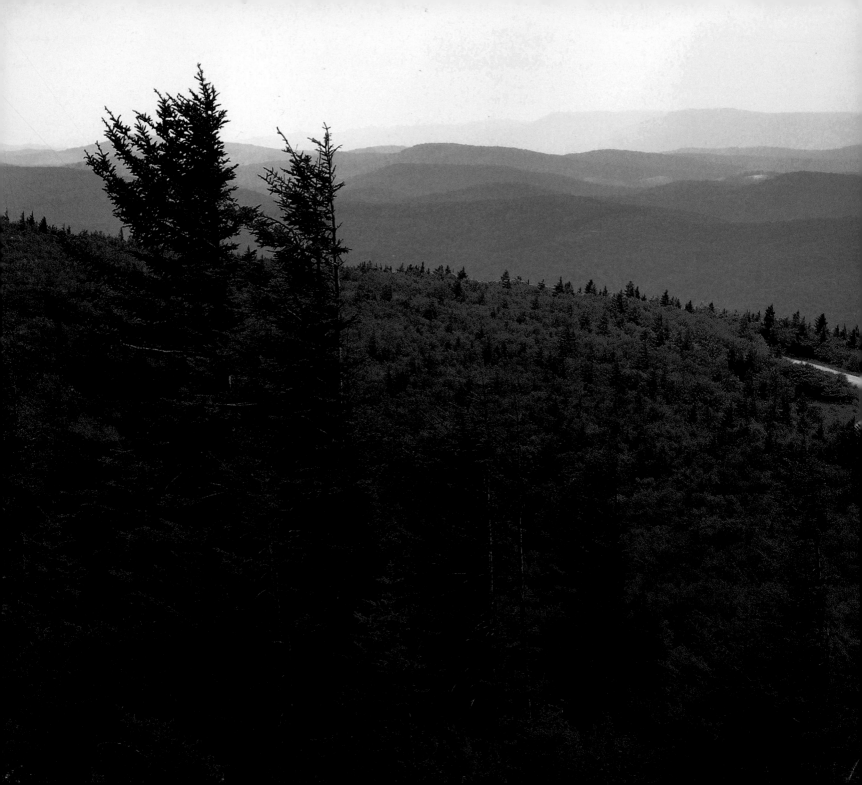

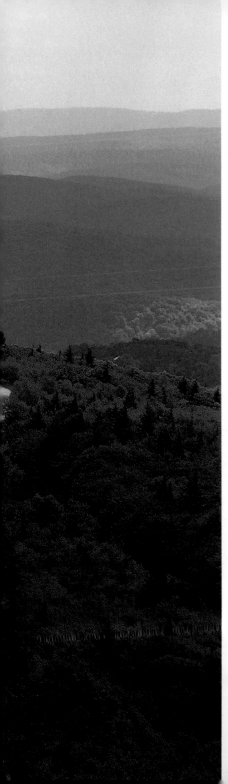

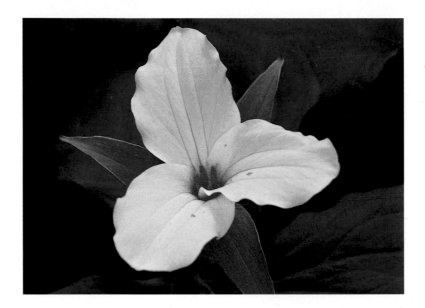

Above: Three white petals characterize the large-flowered trillium, a member of the lily family. BRYAN LEMASTERS

Right: The delicate bloodroot is one of the first spring flowers to bloom. This blossom was photographed in Upsher County. BRYAN LEMASTERS

Left: At 4,861 feet, Spruce Knob is West Virginia's highest peak. Vegetation here has adapted to the harsh, windswept environment. STEVE SHALUTA

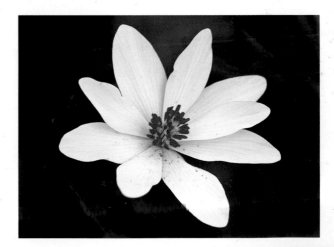

Right: The lovely Spring Run Falls, where water cascades over large boulders, is one of Grant County's many scenic spots. Within Grant County's 478 square miles are the fertile valleys along the South Branch of the Potomac River and its many smaller streams.
BRYAN LEMASTERS

Far right: The Williams River begins on Black Mountain in Pocahontas County and flows west 33 miles to meet the Gauley River in Webster County. The river is a popular setting for camping, hiking, and fishing. BRYAN LEMASTERS

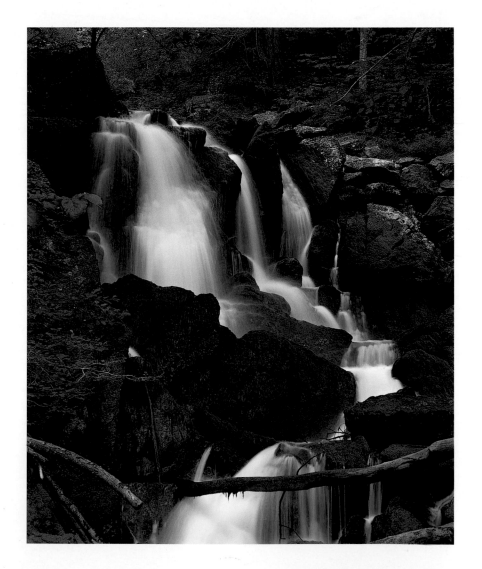

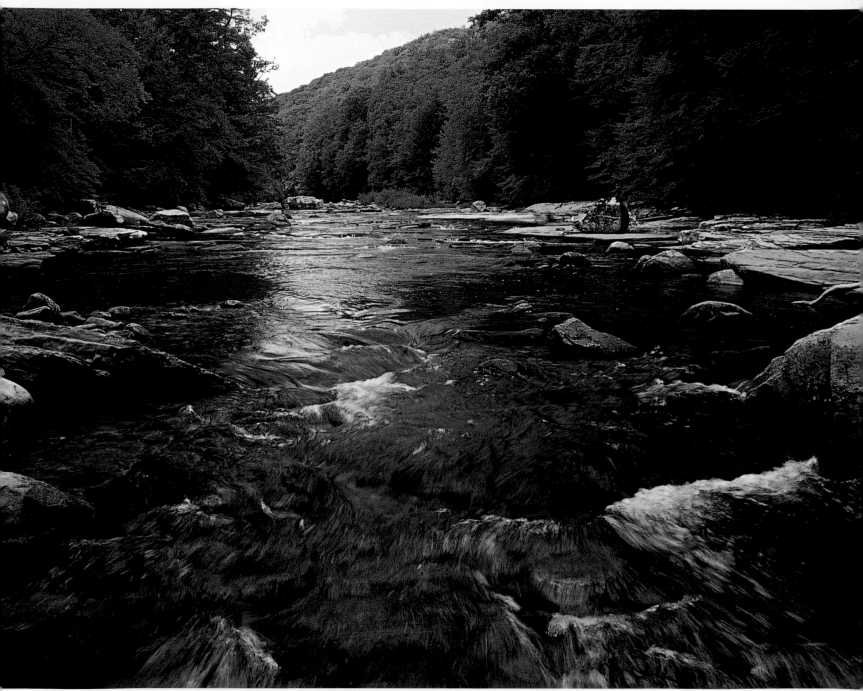

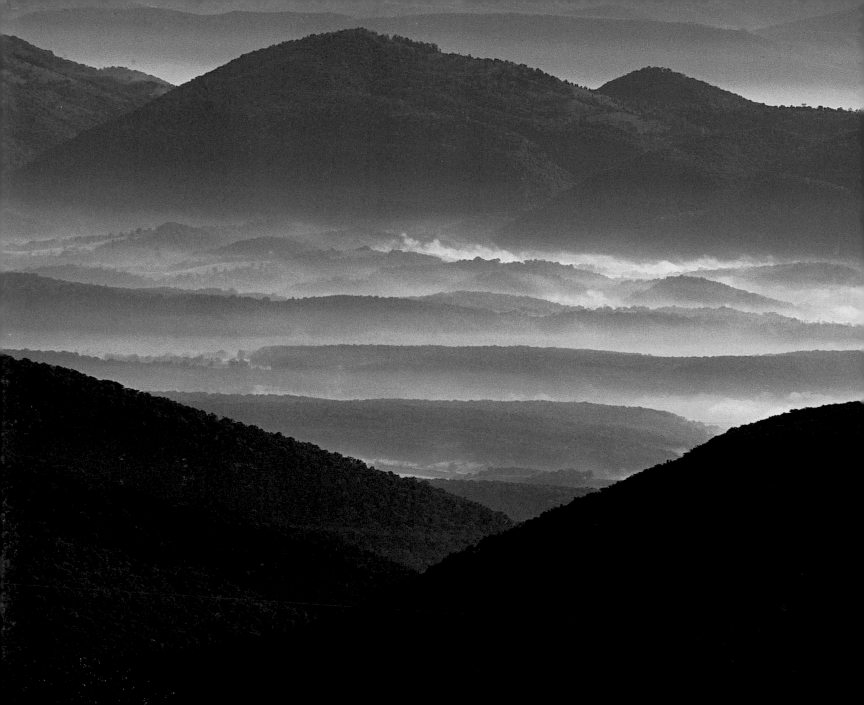

Left: Tranquility settles in like the fog in the Lunice Creek Valley. BRYAN LEMASTERS

Below: R. D. Bailey Lake, tucked into the mountains of Wyoming County, promises a multitude of recreational opportunities. A visitor center provides a scenic overlook of the 630-acre lake. BRYAN LEMASTERS

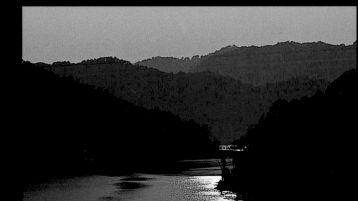

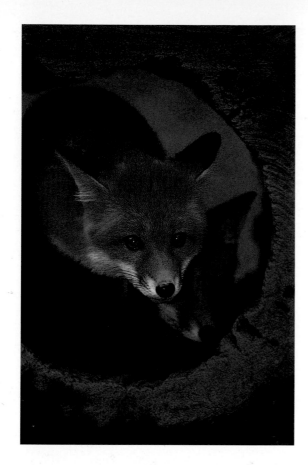

Right: Used for the mining of saltpeter during the Civil War, Organ Cave near Lewisburg contains almost 40 miles of passages, although only a small portion of the cave is open to the public. Its name was derived from its largest formation, which resembles a large church organ. STEVE SHALUTA

Below: A white-tailed buck located in Canaan Valley State Park, the largest wetland complex in West Virginia. STEVE SHALUTA

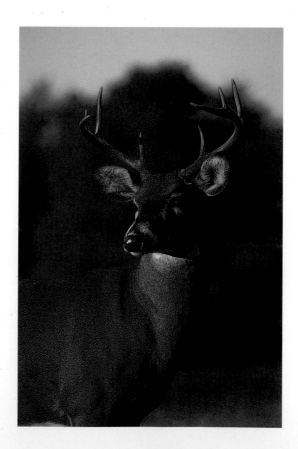

Above: These wary red fox kits are starting to explore the world outside their den. Although primarily nocturnal, the red fox will occasionally venture out during the day. STEVE SHALUTA

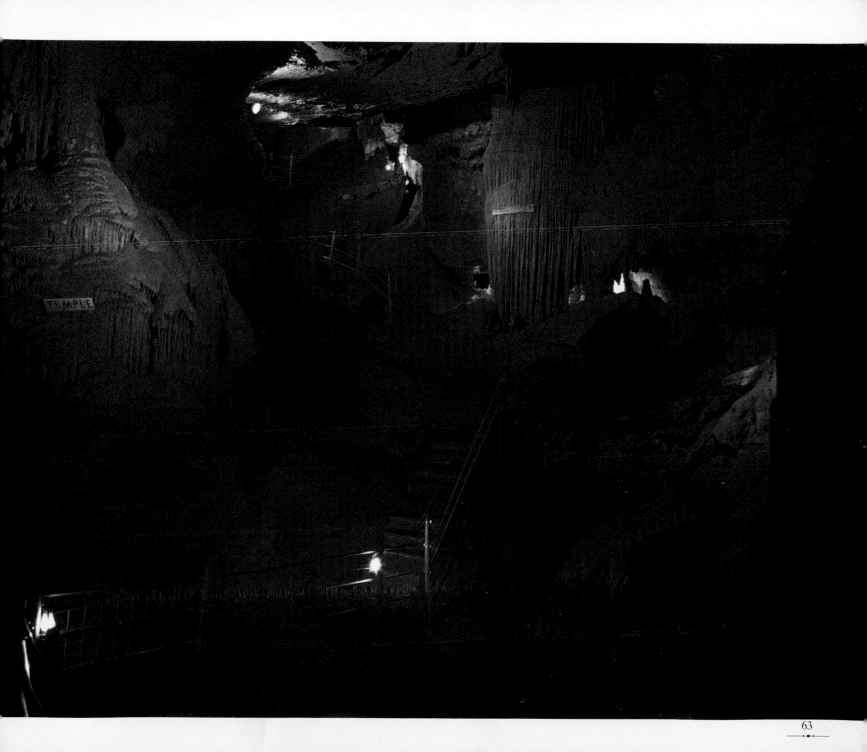

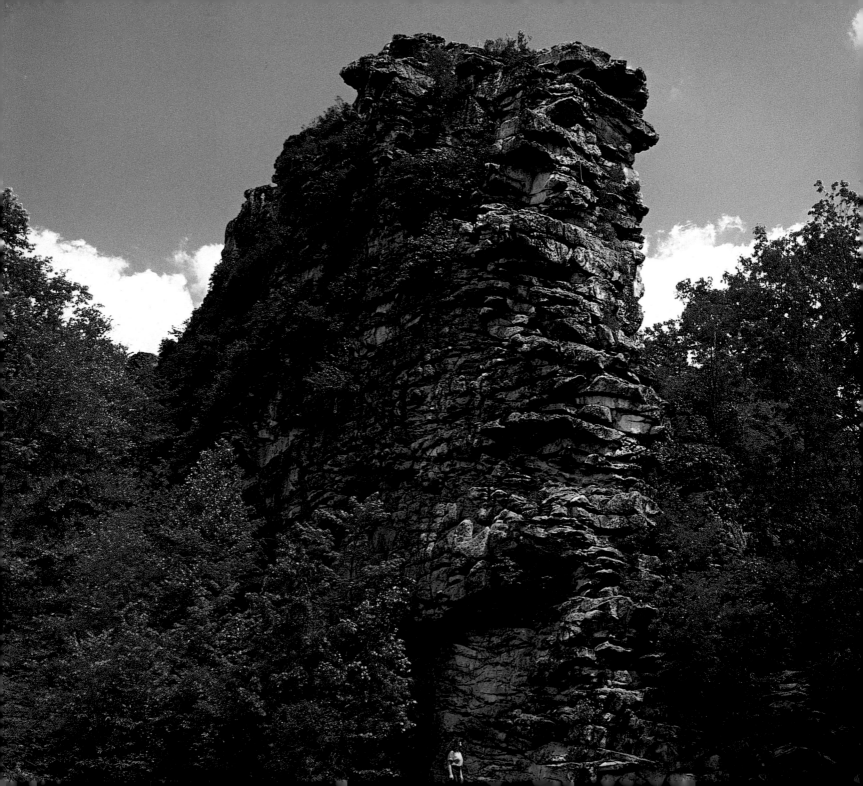

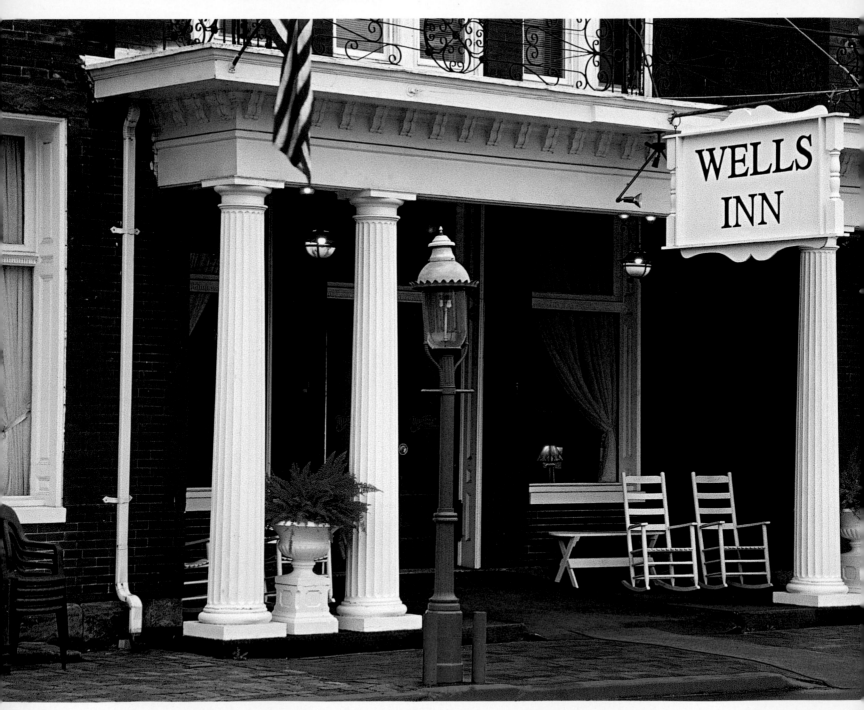

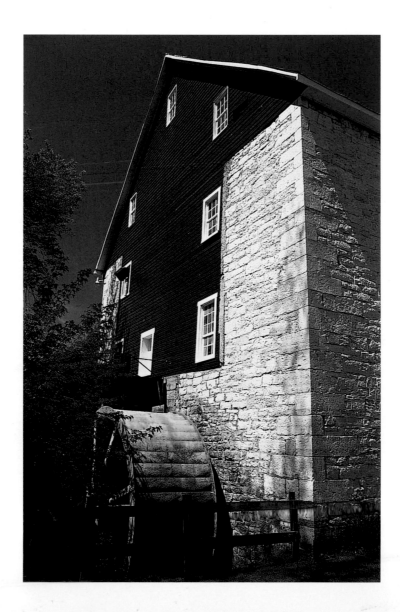

Left: The Bunker Hill Mill in Berkeley County, the oldest mill in West Virginia, was originally constructed around 1735 and boasted two tandem Fitz Water Wheels. It was later known as the Cline & Chapman Roller Mill. BRYAN LEMASTERS

Far left: The Wells Inn, which recently underwent a 1 million-dollar facelift, opened in 1895, shortly after the discovery of oil in Sistersville. BRYAN LEMASTERS

Right: Moncove Lake State Park, in the southeastern corner of the state, is a popular spot for bird watching or fishing. STEVE SHALUTA

Below: A stately great blue heron surveys the lush setting of Cedar Creek State Park, a recreational area that provides adventurers with 2,483 acres of rolling hills, wide valleys, and an inviting lake. BRYAN LEMASTERS

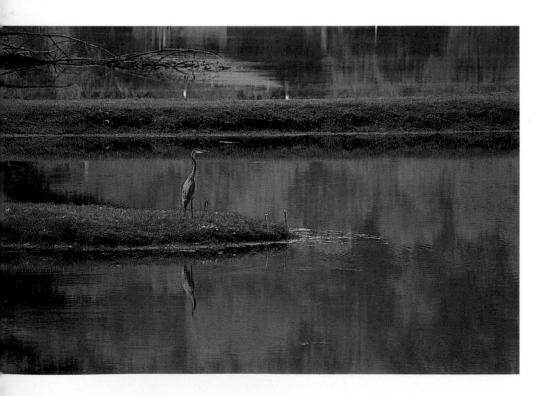

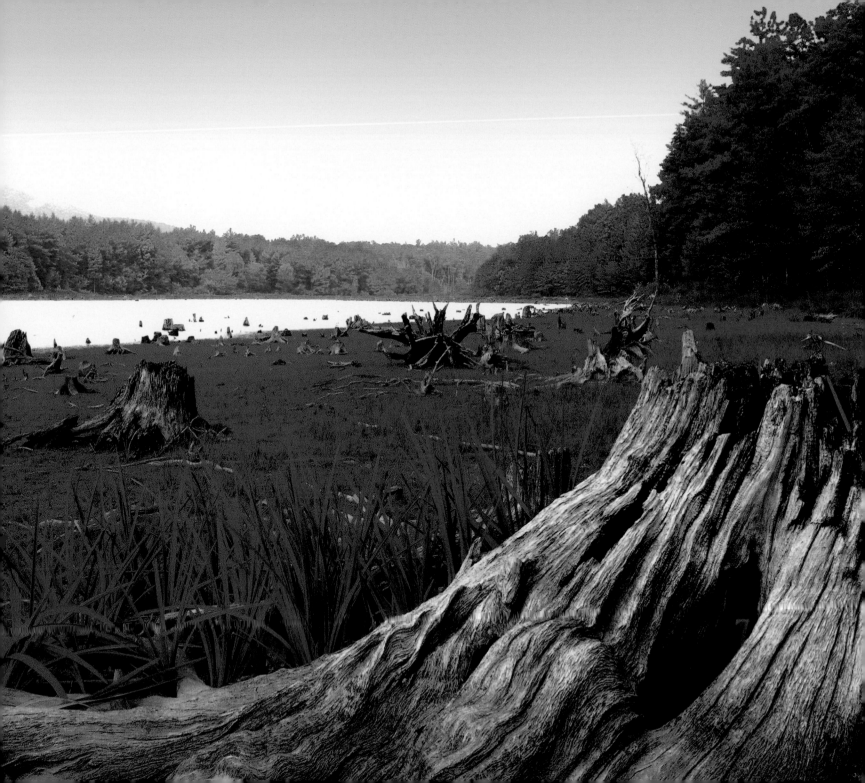

Left: The sun slips behind the trees along West Virginia's Highland Scenic Highway, a beautiful corridor that curves through the mountainous Allegheny Highlands and Plateau that rise from 2,325 to more than 4,500 feet. BRYAN LEMASTERS

Below: Feathery seedpods take on the colors of the sunset. BRYAN LEMASTERS

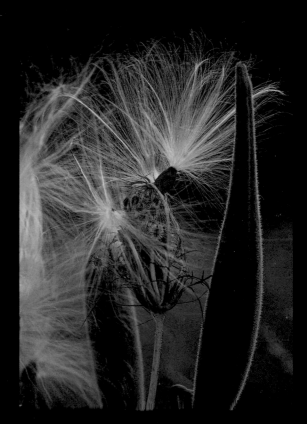

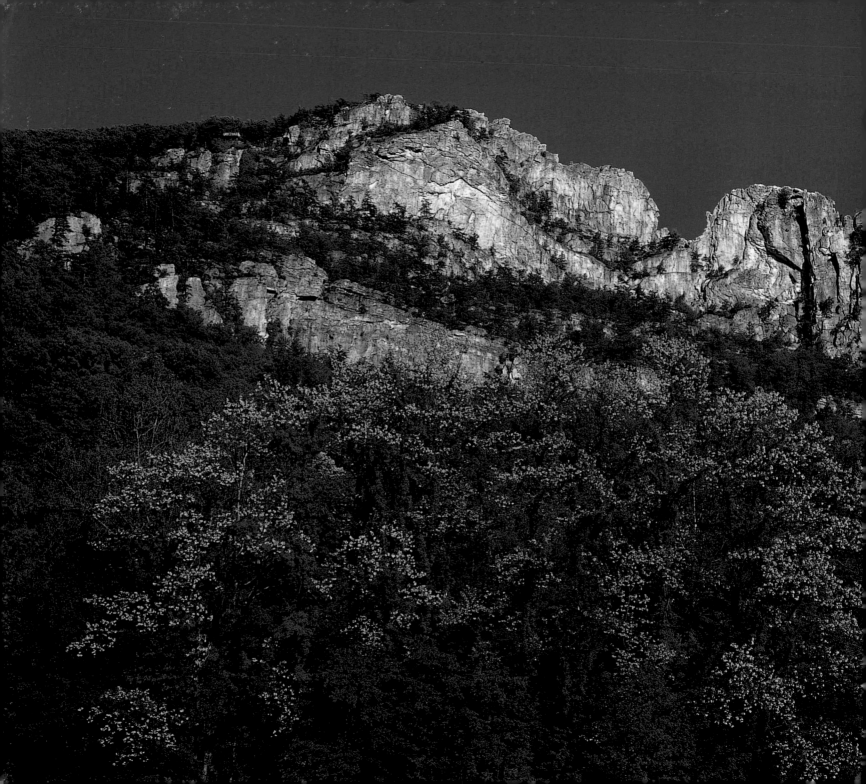

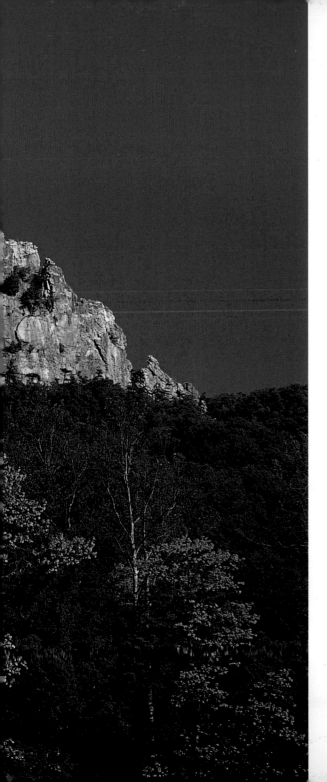

Left: The Tuscarora sandstone of Seneca Rocks in rural Pendleton County attracts both those who want to admire its reaches from afar and those who wish to scale its challenging faces. STEVE SHALUTA

Below: Near the community of Gauley Bridge, Cathedral Falls plunges 60 feet over rocky ledges. BRYAN LEMASTERS

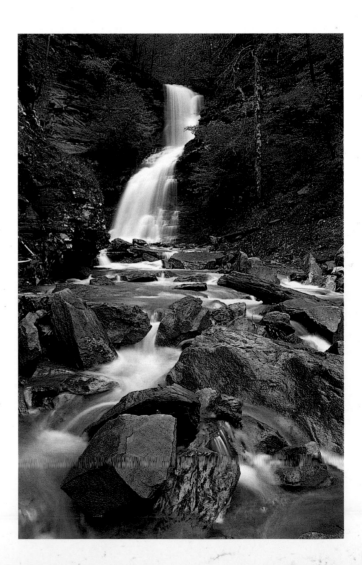

Right: A hiking trail around Spruce Knob Lake offers an unparalleled view of the brilliant fall colors. The lake is regularly stocked for trout fishing. STEVE SHALUTA

Below: The moon gleams through a craggy gap in the vertical wall of Seneca Rocks, a formation that rises almost 900 feet above the North Fork of the South Branch of the Potomac River. Purchased by the federal government in 1969, the site is managed by the Monongahela National Forest Service. STEVE SHALUTA

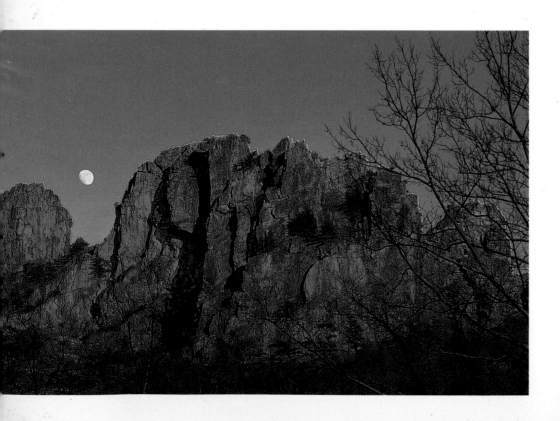

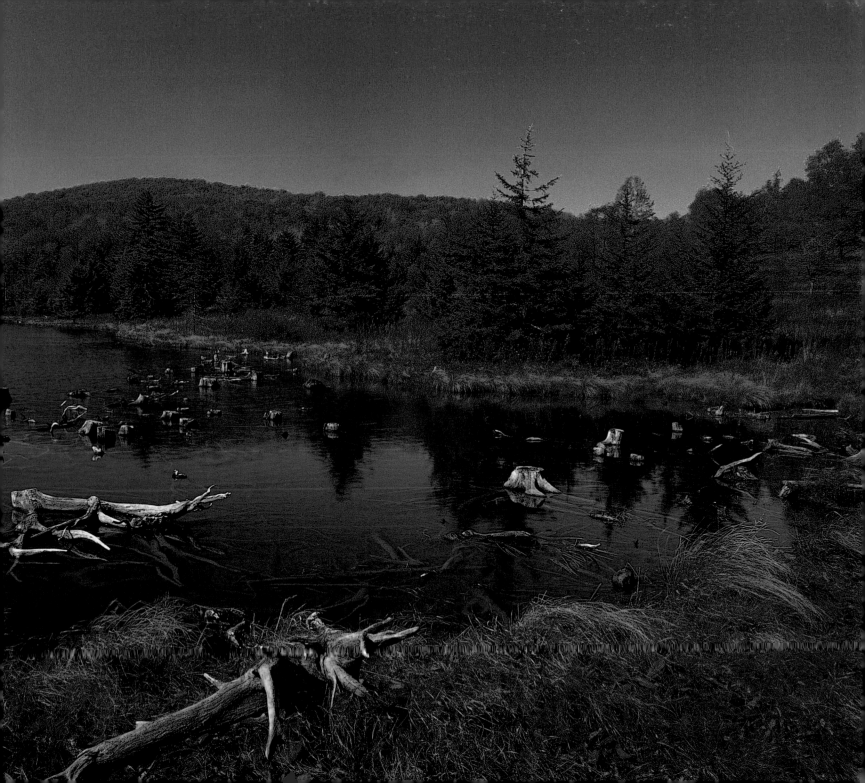

Right: A field of summer dandelions brightens the day for passersby near Brandonville in Preston County. BRYAN LEMASTERS

Below: The prickly pear cactus, shown here, thrives in the shale barren ecosystem east of the Allegheny Front. BRYAN LEMASTERS

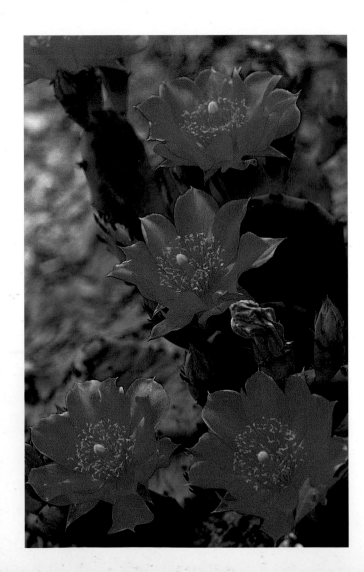

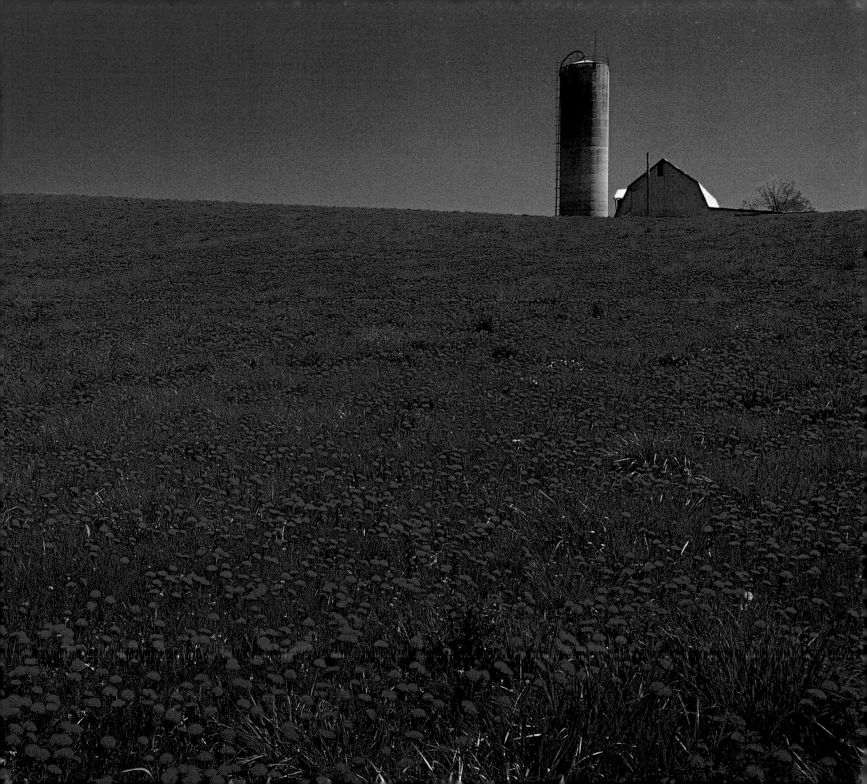

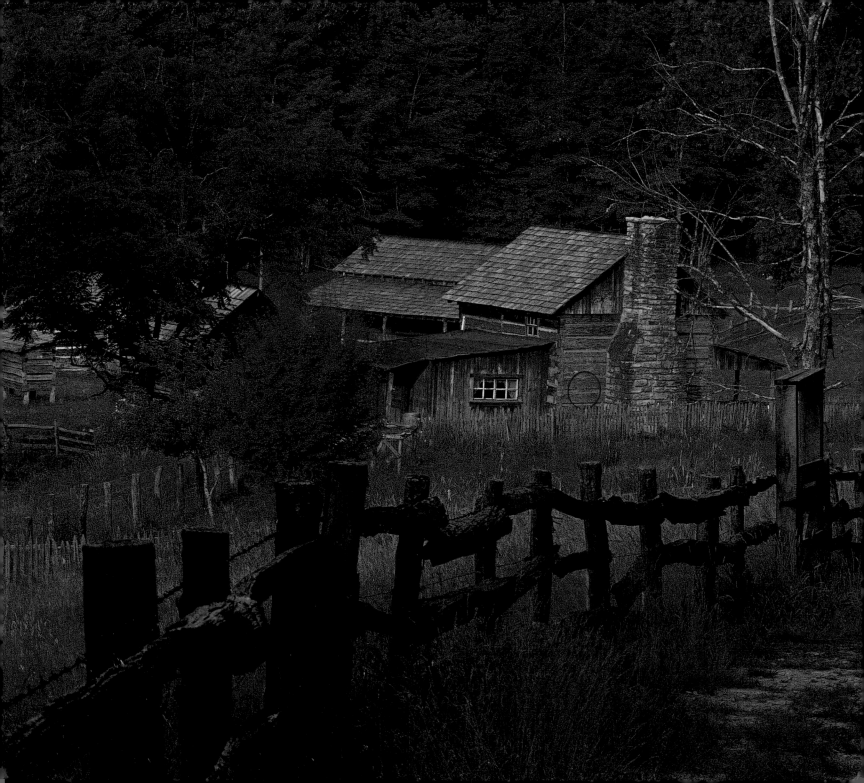

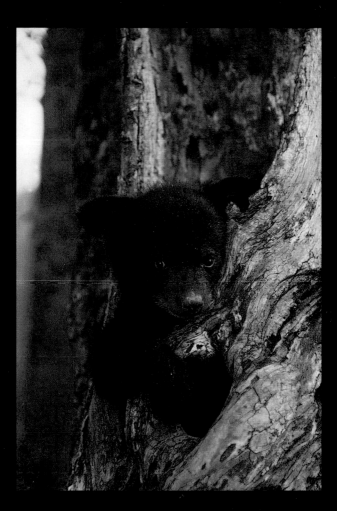

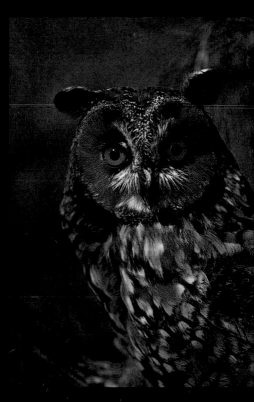

Above: Though the young black bear in a hollow apple tree looks fetching, his protective mother is most likely close by. STEVE SHALUTA

Right: The steady gaze of a long-eared owl, a primarily nocturnal bird of prey. STEVE SHALUTA

Left: Twin Falls State Park in Wyoming County offers a glimpse into the pioneer days of the nineteenth century as well as an 18-hole golf course and accommodations ranging from a 20-room lodge to secluded cottages. STEVE SHALUTA

Bryan Lemasters

Bryan Lemasters is a self-taught photographer who has worked as a professional since 1996. He specializes in West Virginia landscape, nature, and panoramic photography. Bryan has been a contributing photographer to *Wonderful West Virginia* magazine, with approximately seventy images, three covers, and three articles to his credit. His images have also been used by the West Virginia High Technology Foundation and the West Virginia Chapter of The Nature Conservancy and appear in regional calendars. In West Virginia, he has exhibited his works at the Alan B. Moliohan Innovation Gallery in Fairmont, the Canaan Valley National Wildlife Refuge, and the Francis Creative Arts Center.

www.bryanlemasters.com

Steve Shaluta

Steve Shaluta left a 15-year career as a locomotive engineer to become a professional photographer in 1985. In addition to his successful freelance photography business, he also works as a staff photographer for the West Virginia Division of Tourism.

Steve's images have appeared in countless advertisements, newspaper stories, and magazines, with more than 300 covers to his credit. He is the sole photographer for five books and has contributed images to more than 50 titles.

www.steveshaluta.com